KEEP CALM FOR MENTAL HEALTH

Coloring Book for Adults and Children

(Mandala, Best Animals, Horse, Cat, Dog, Flower, Butterfly, Garden, Forest and other patterns)

Fosten Art & Alex Fosten

ISBN-13: 978-1537481395

ISBN-10: 1537481398

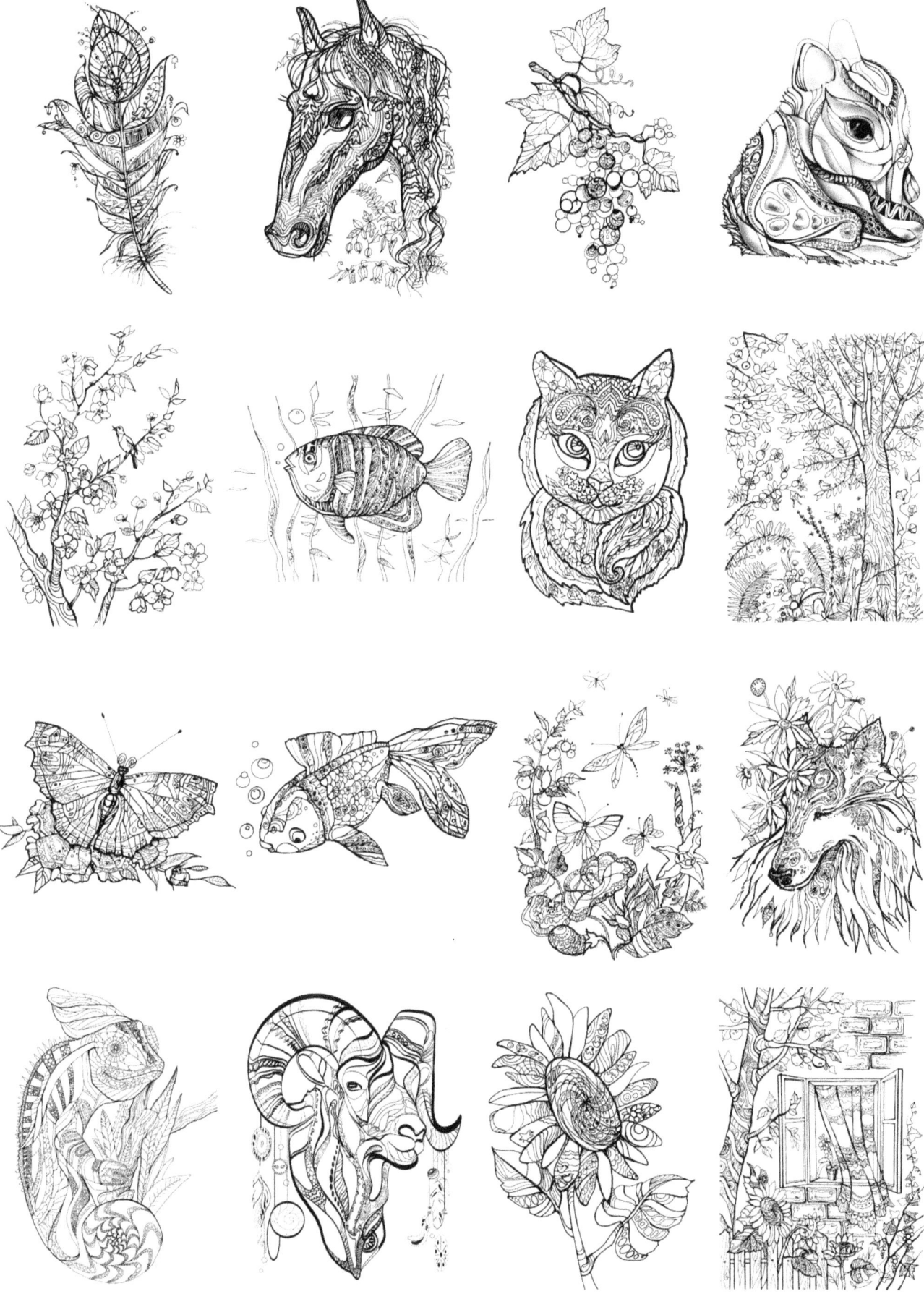

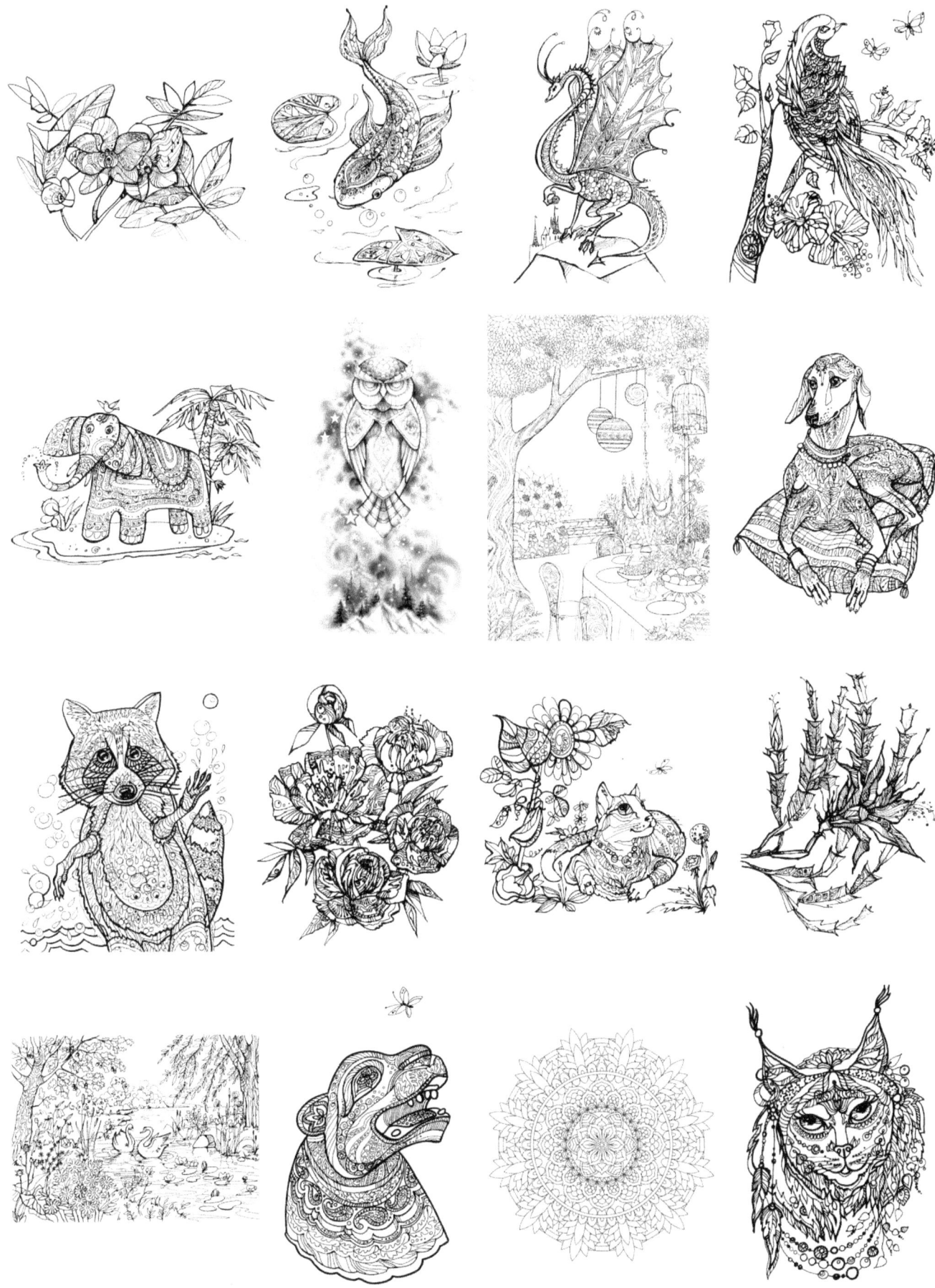

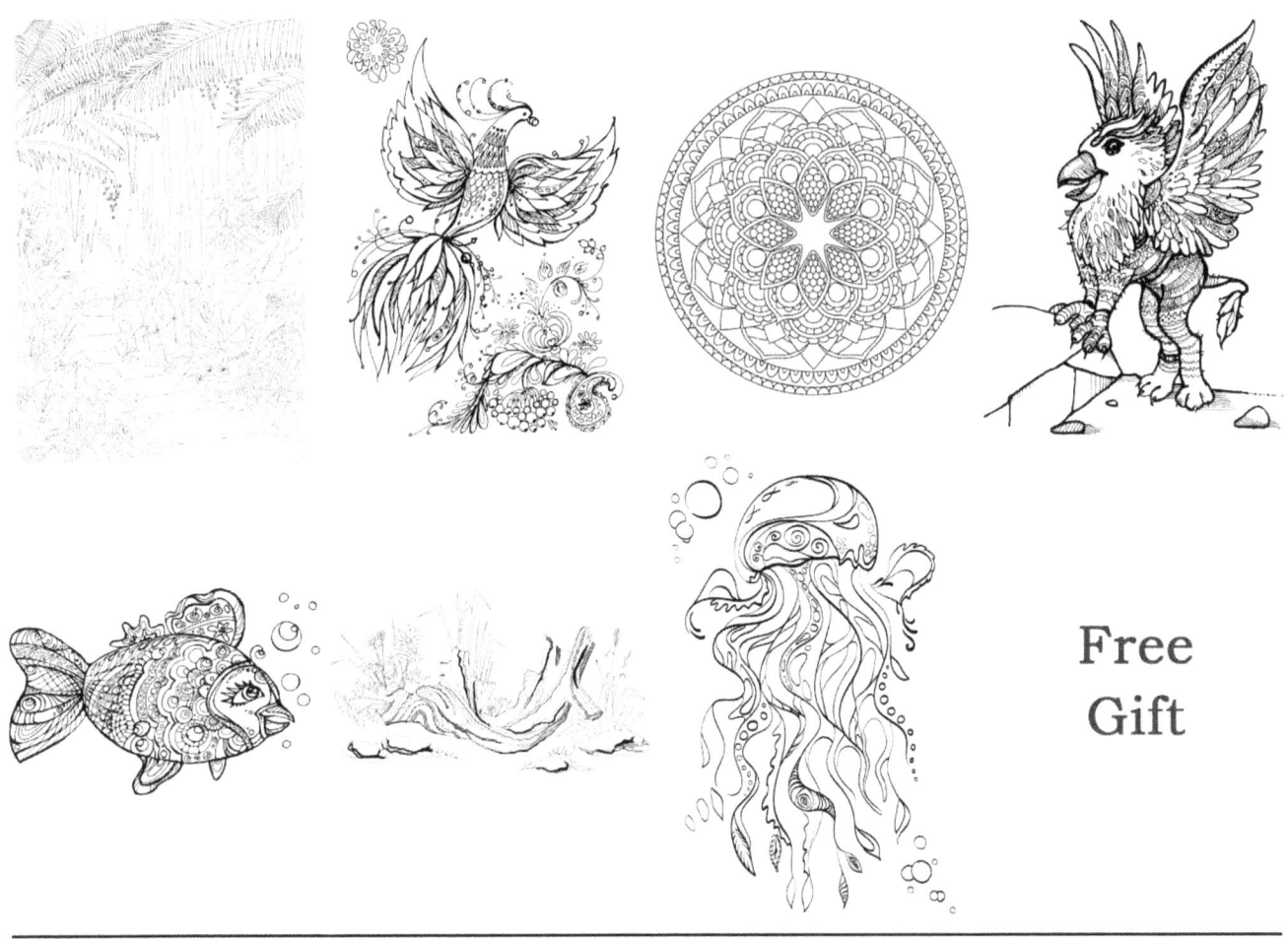

Attention!
If you want to paint with watercolors, watercolor pencils, markers or felt-tip pens – we'd recommend you to place a blank sheet of paper or cardboard under the page being colored to prevent the colors from getting through the paper to the next page.

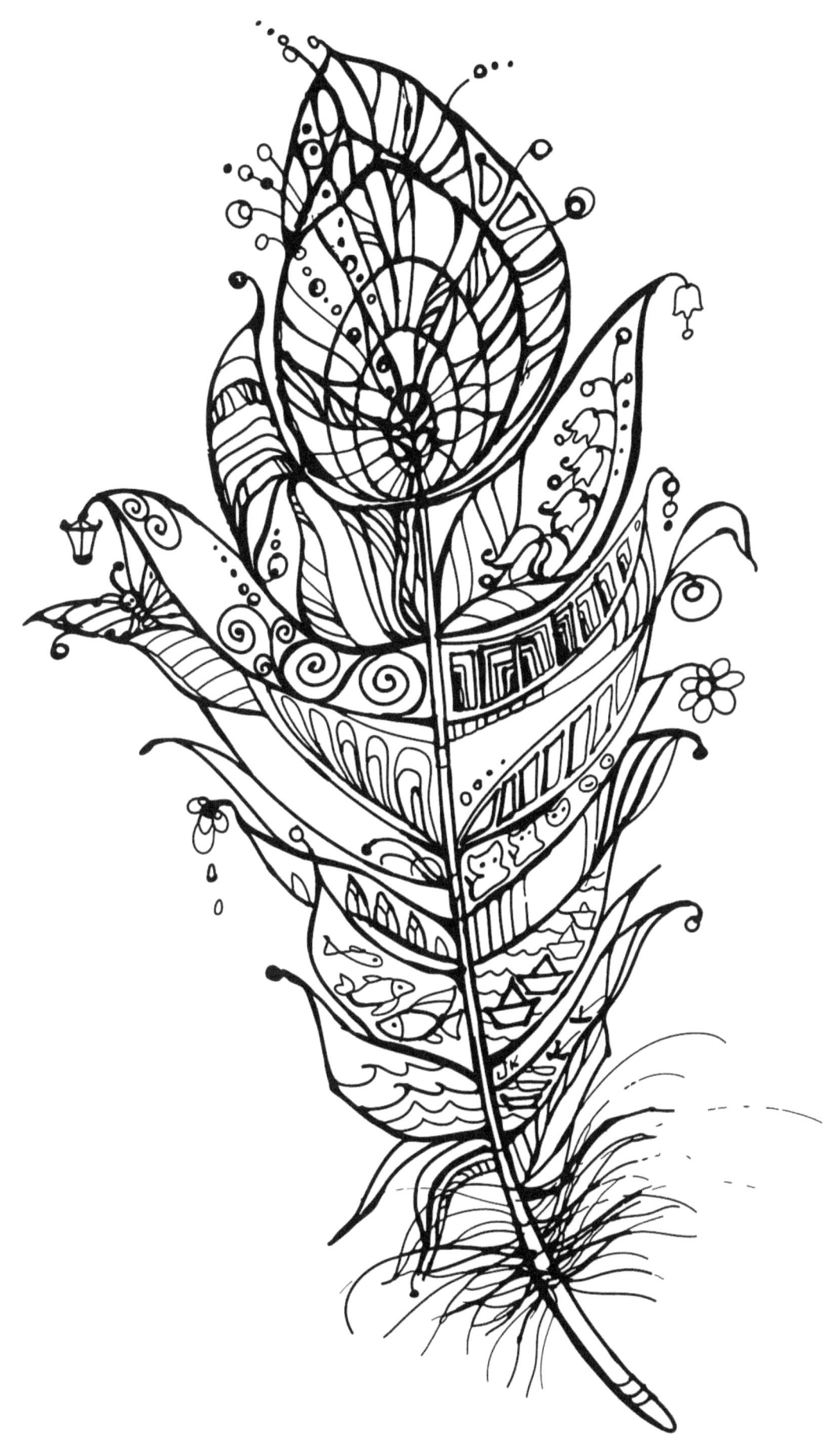

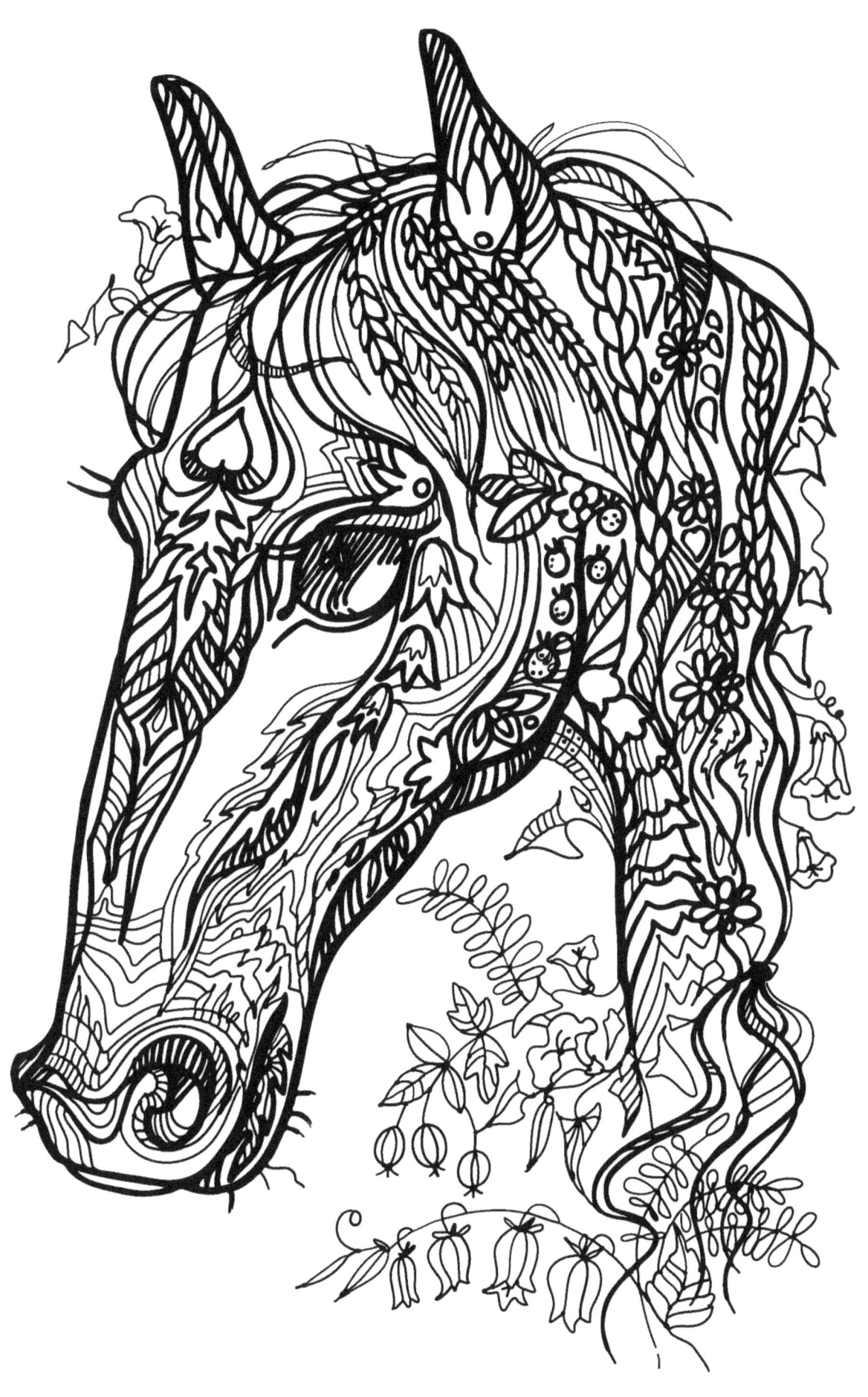

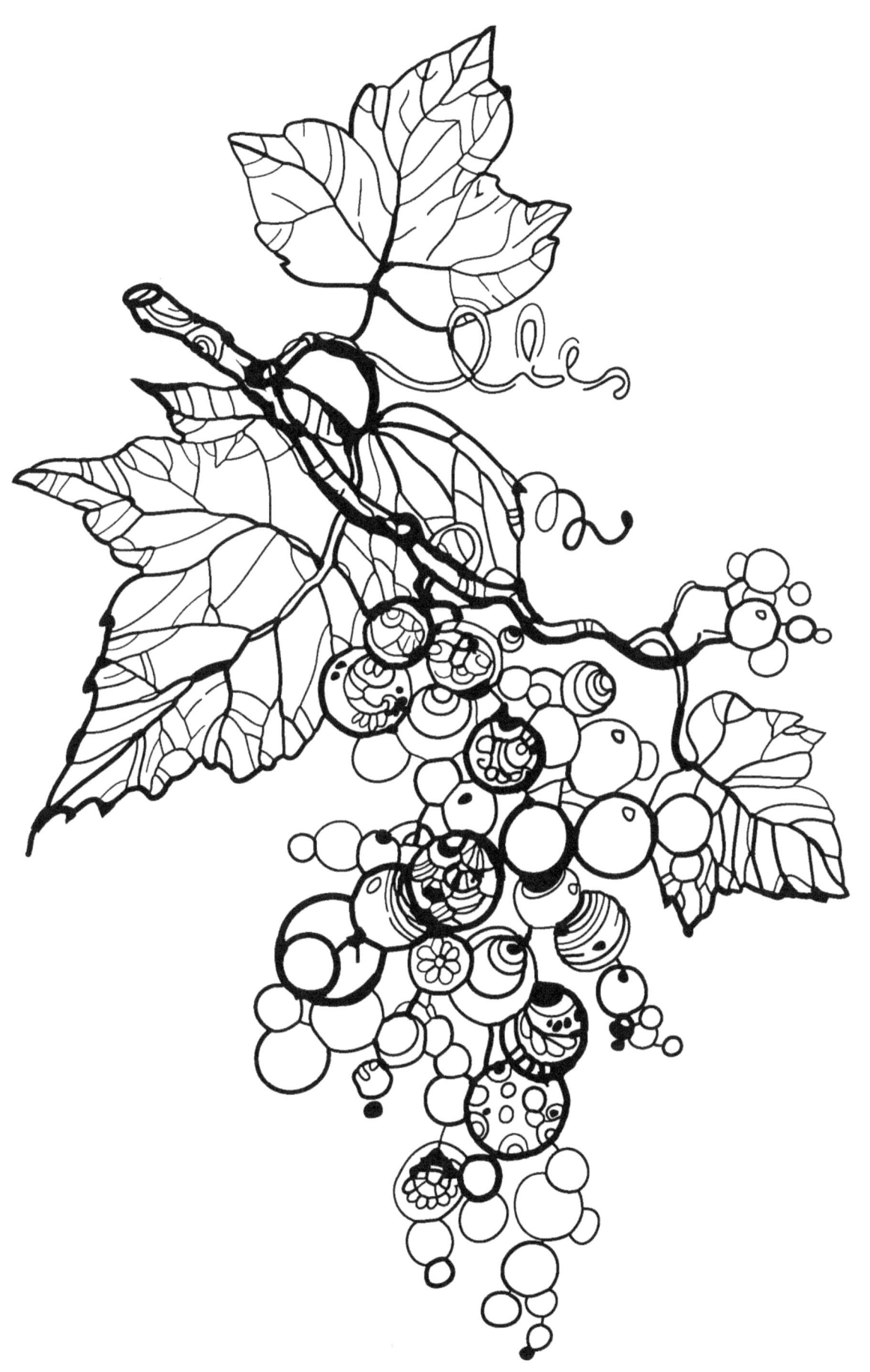

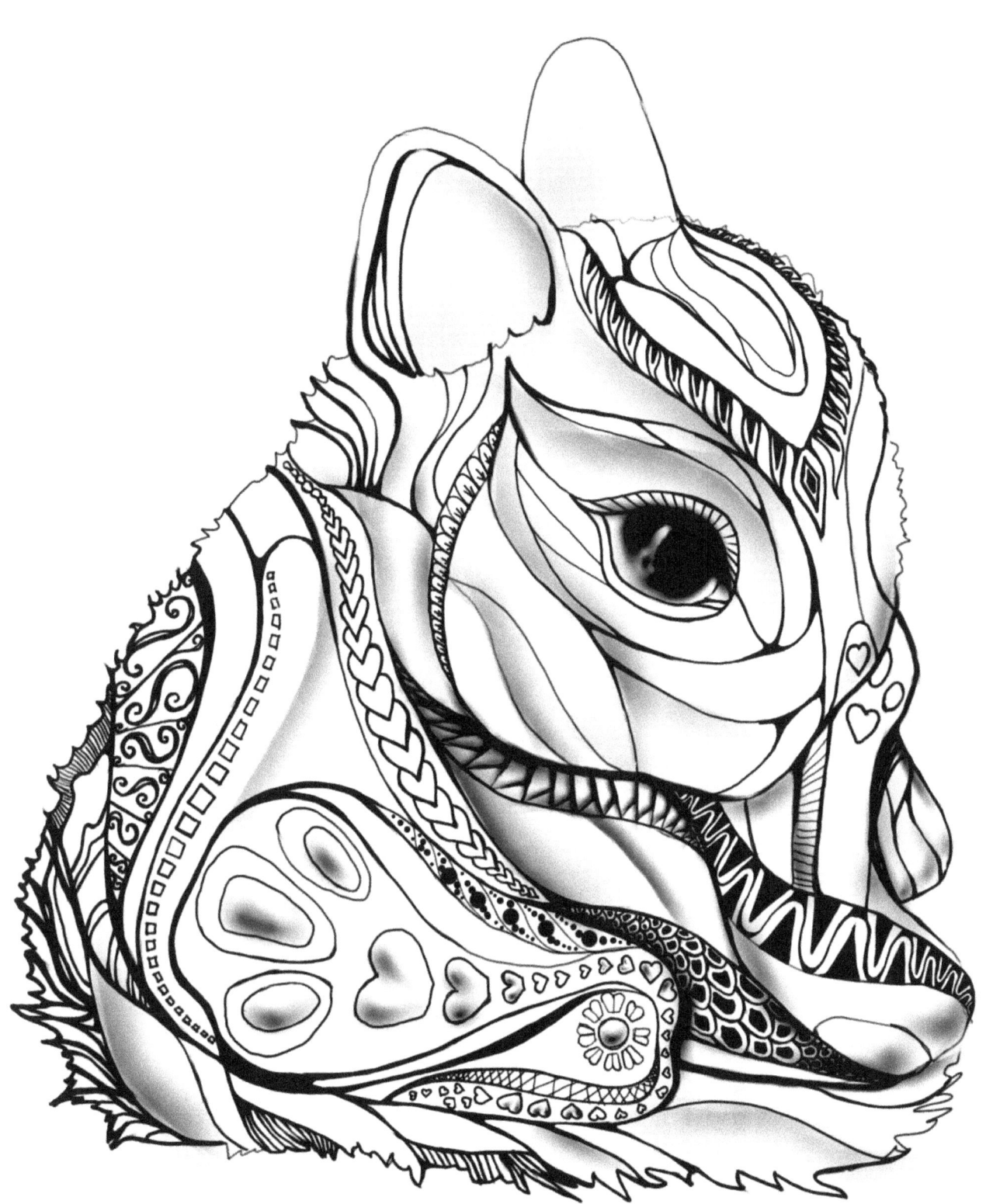

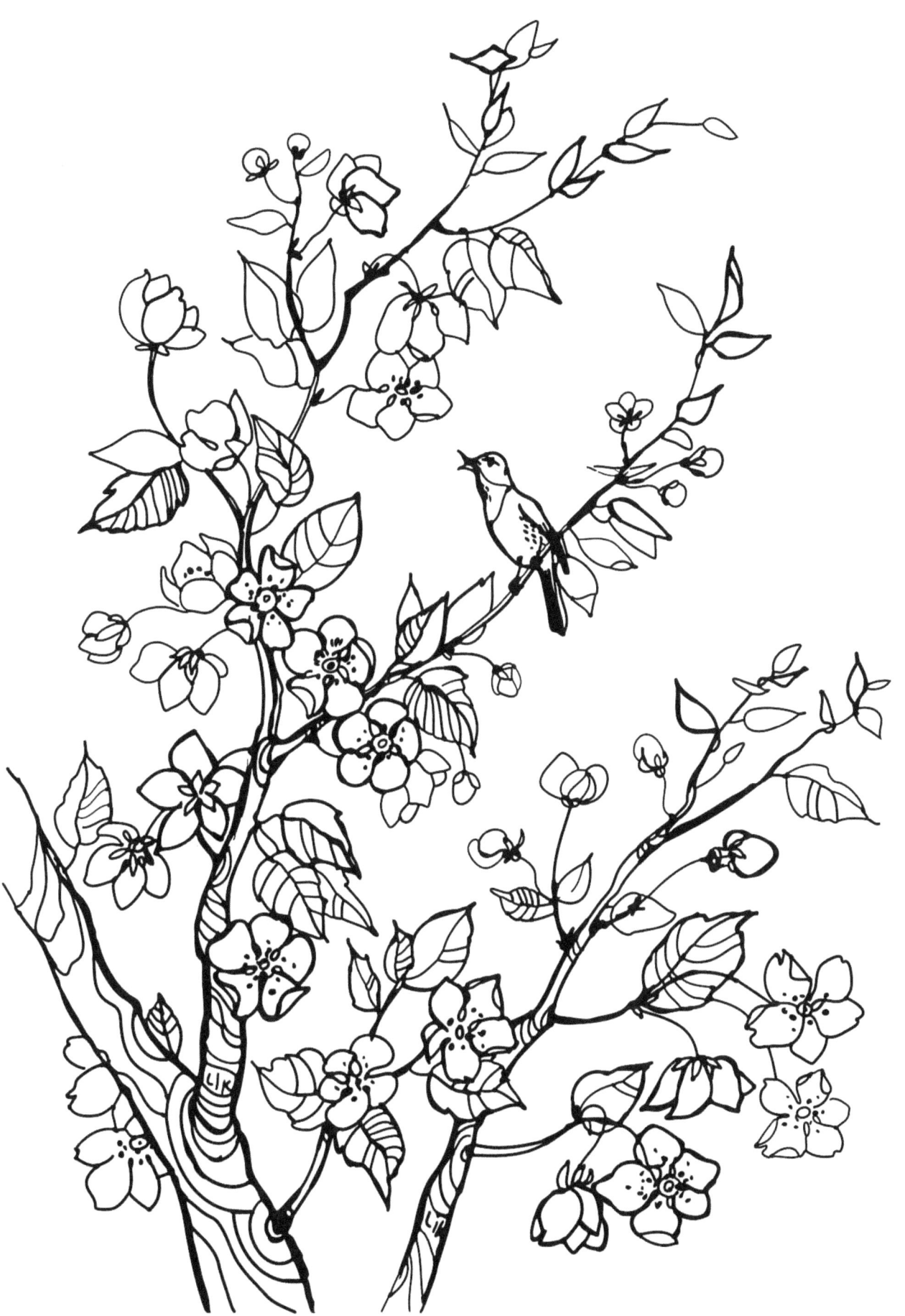

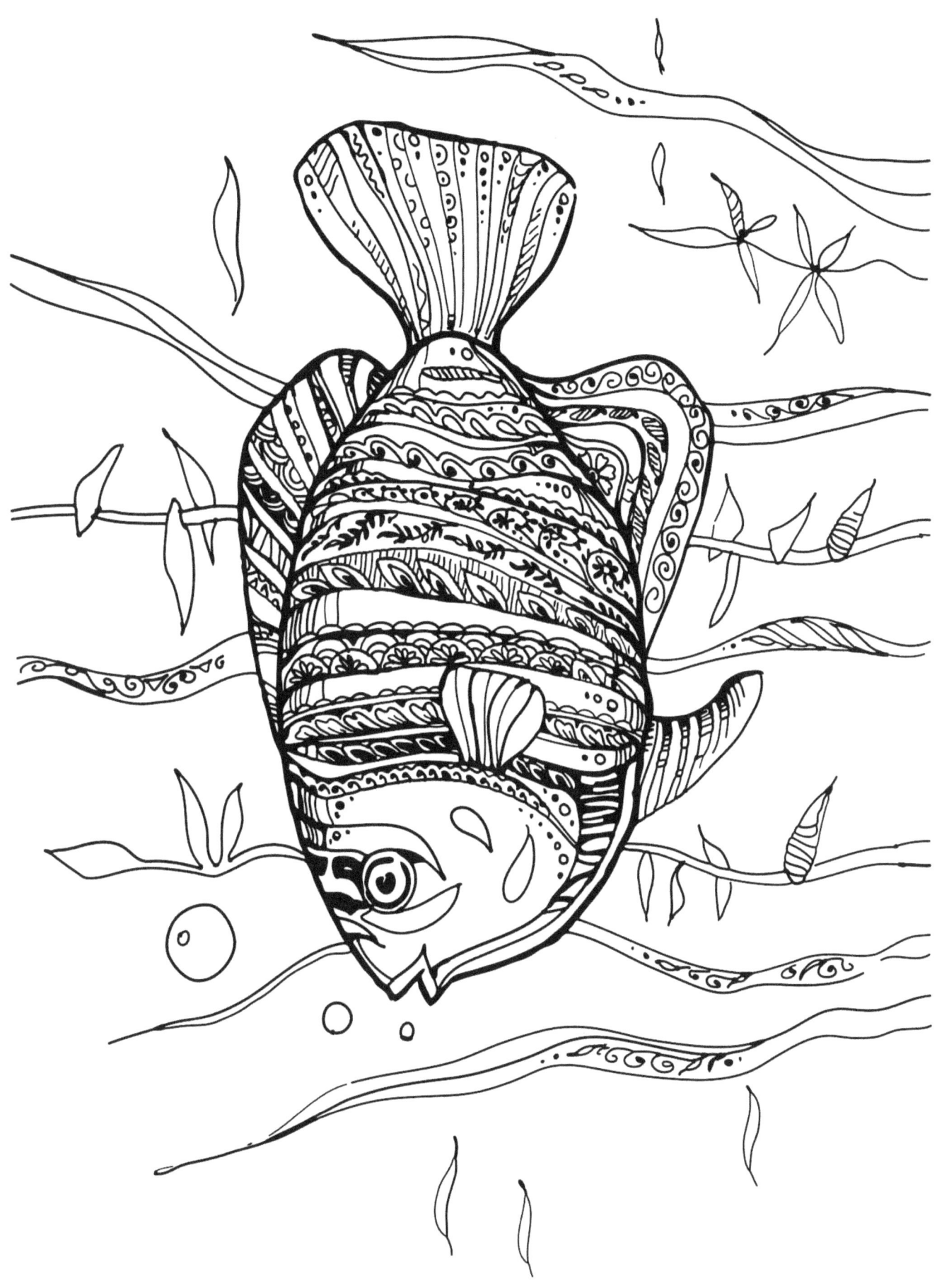

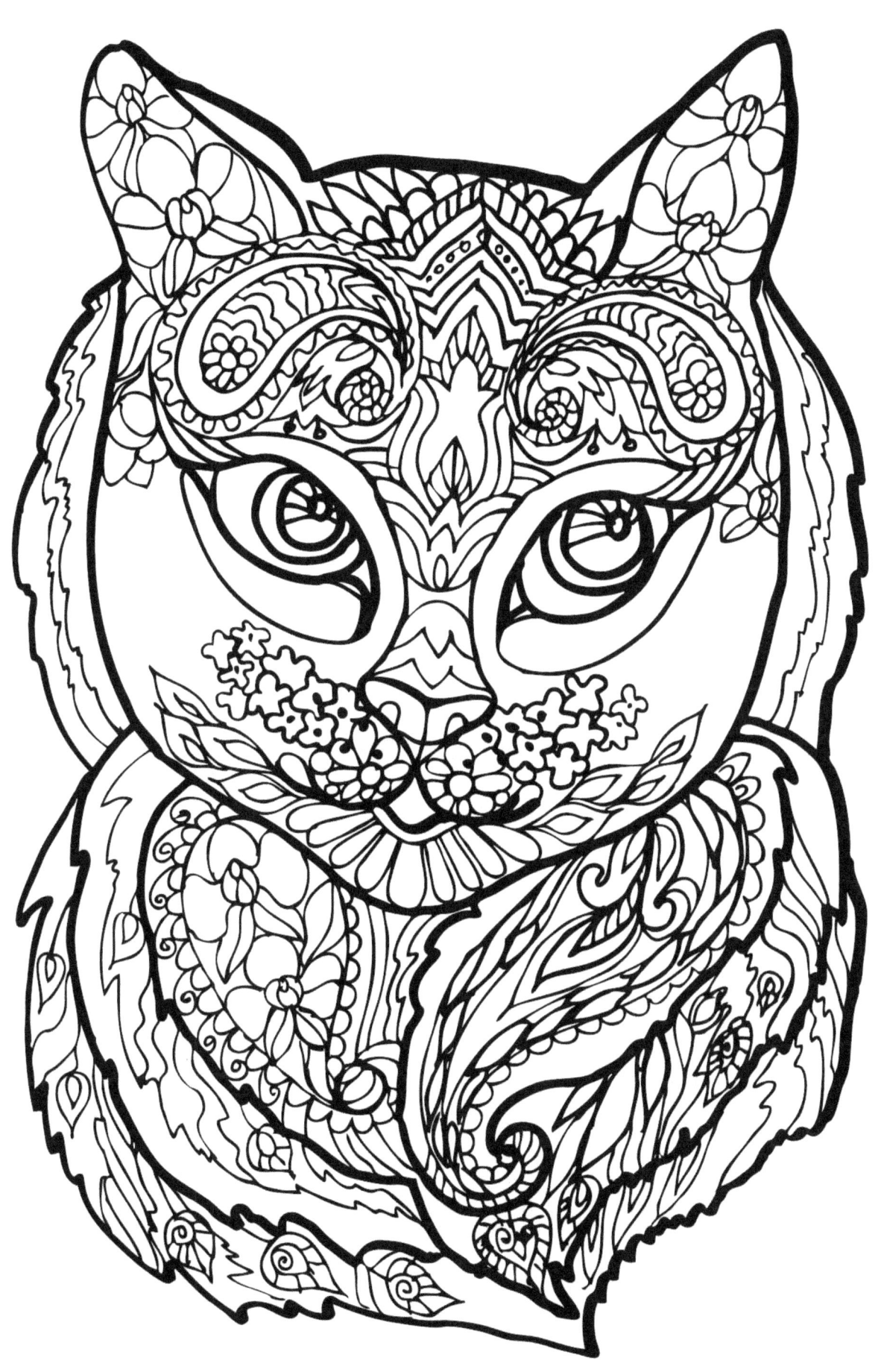

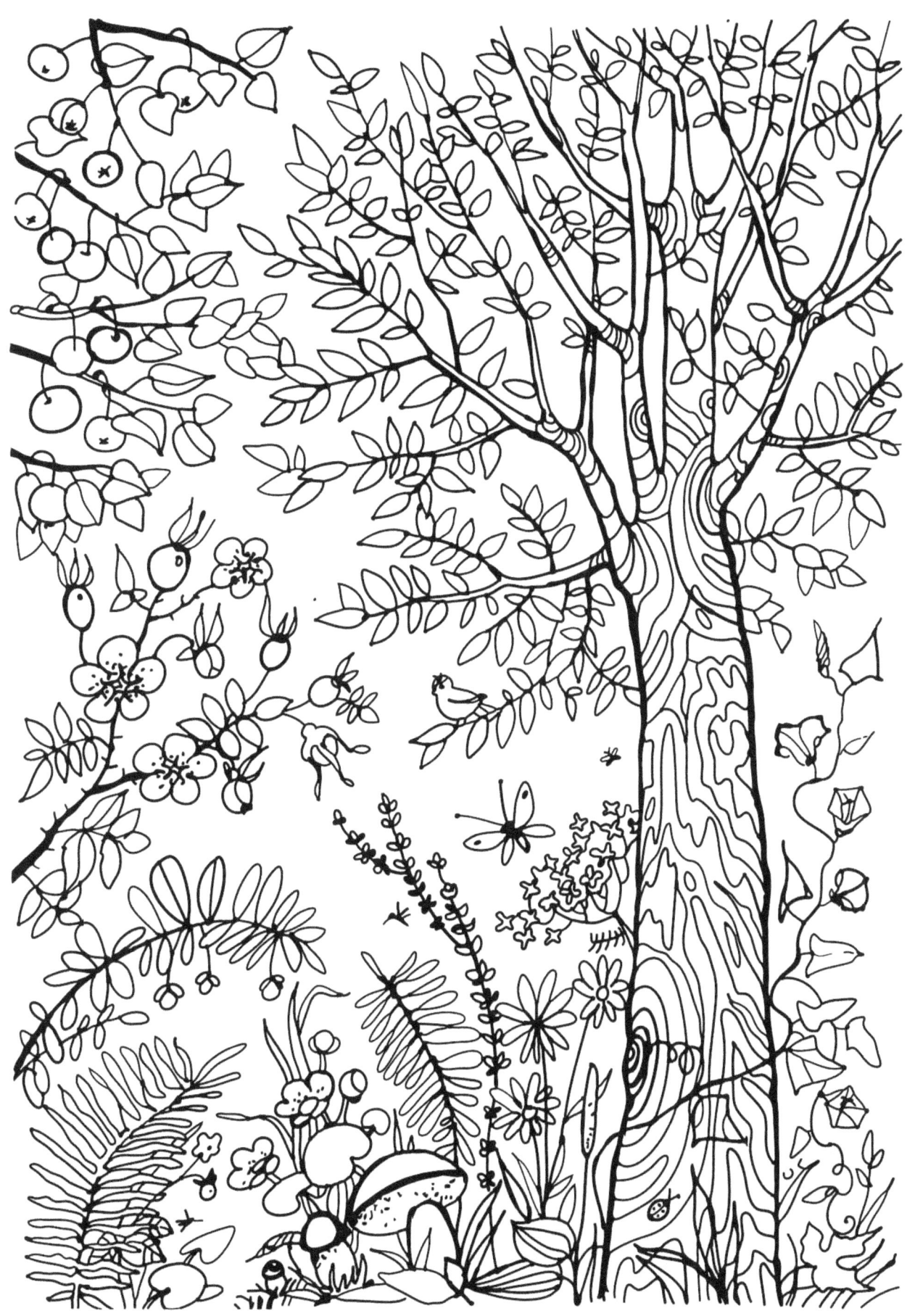

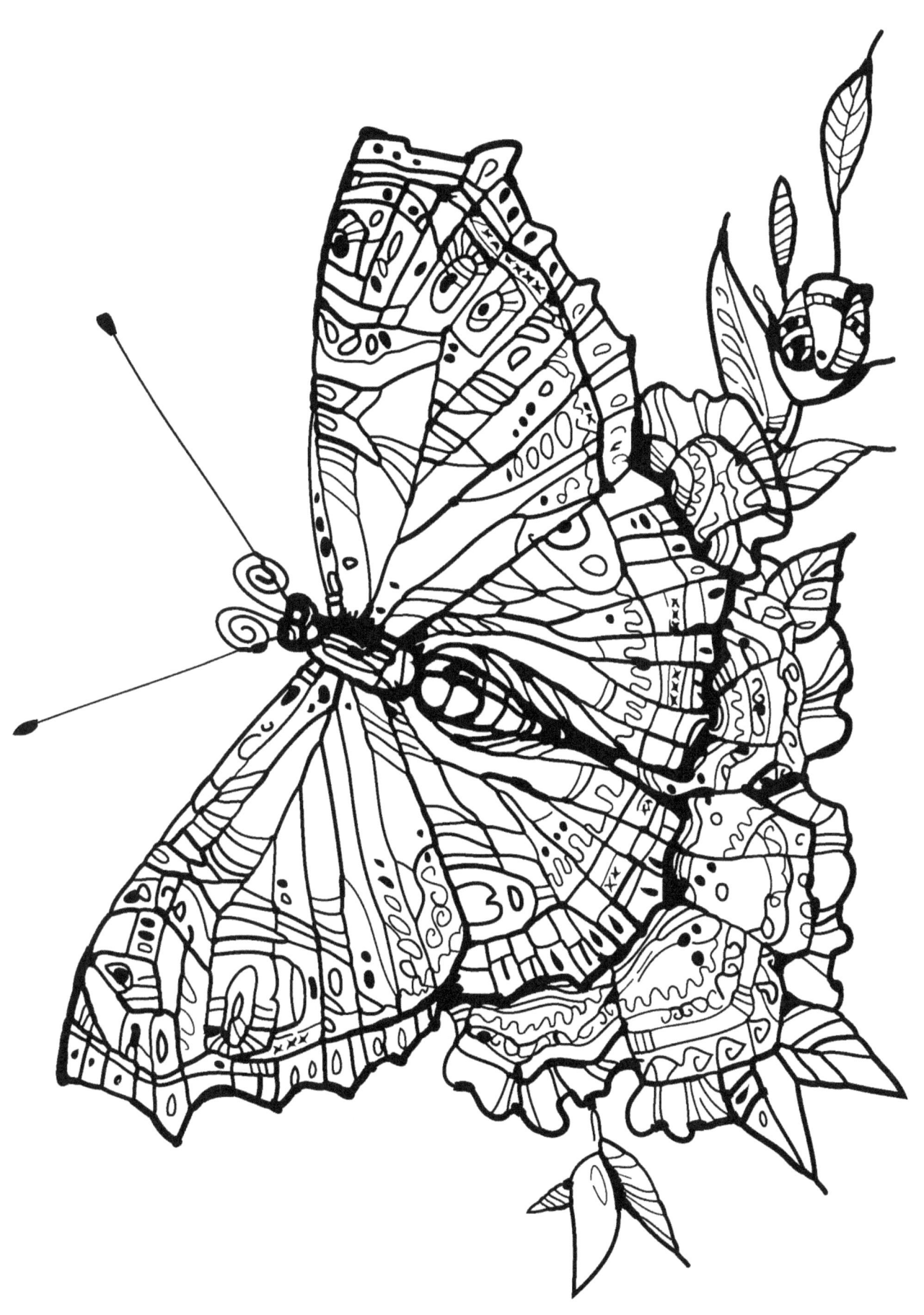

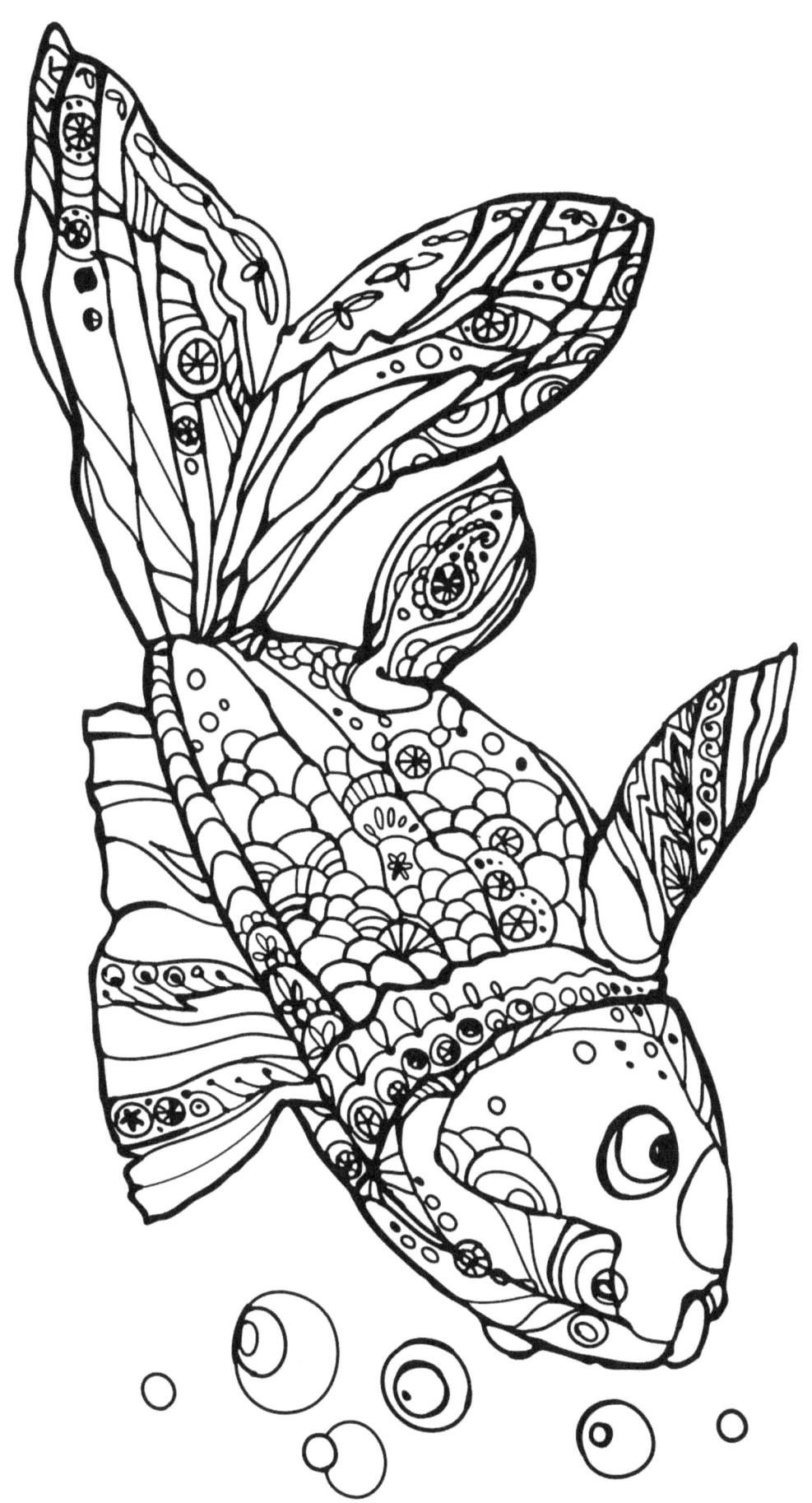

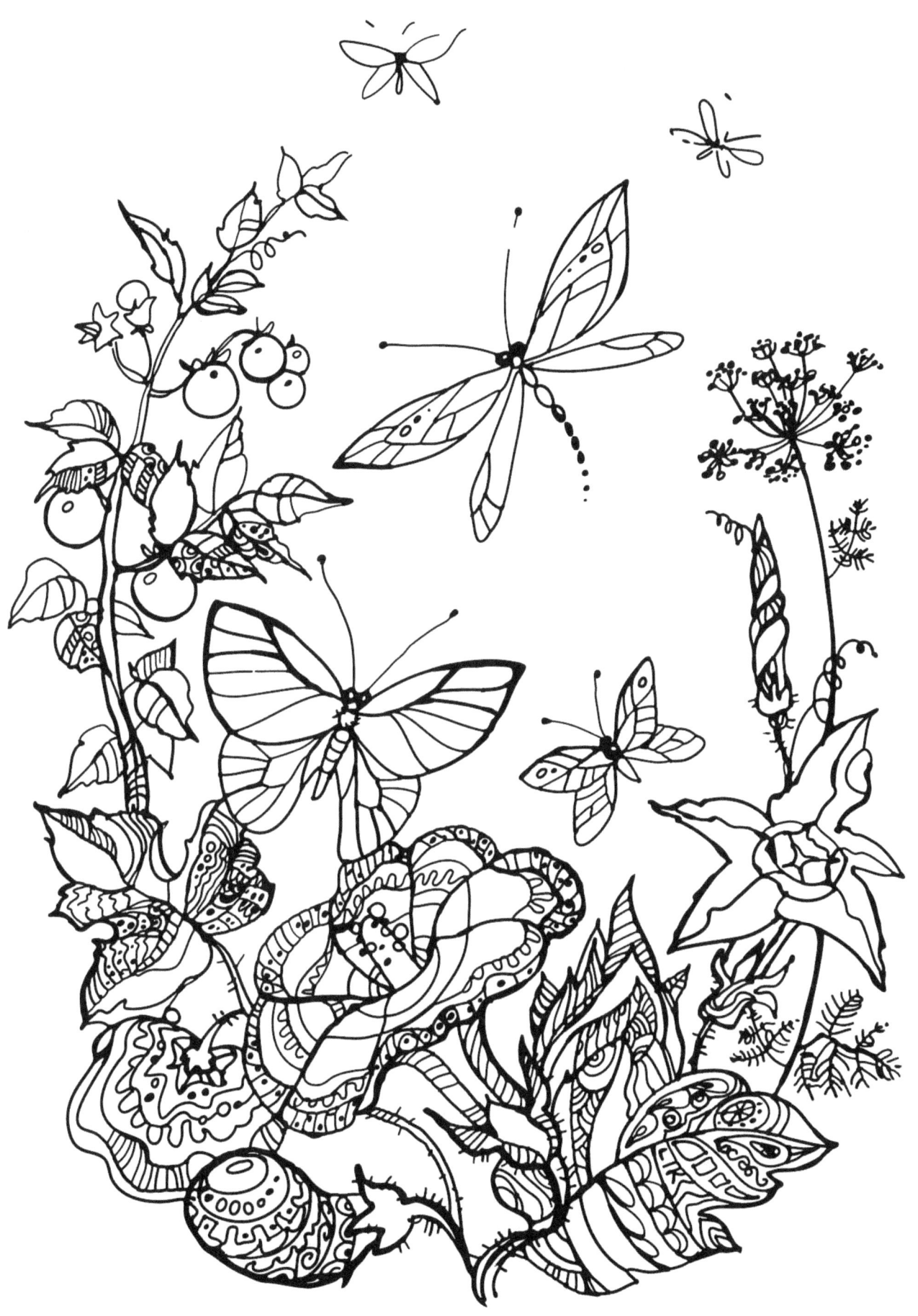

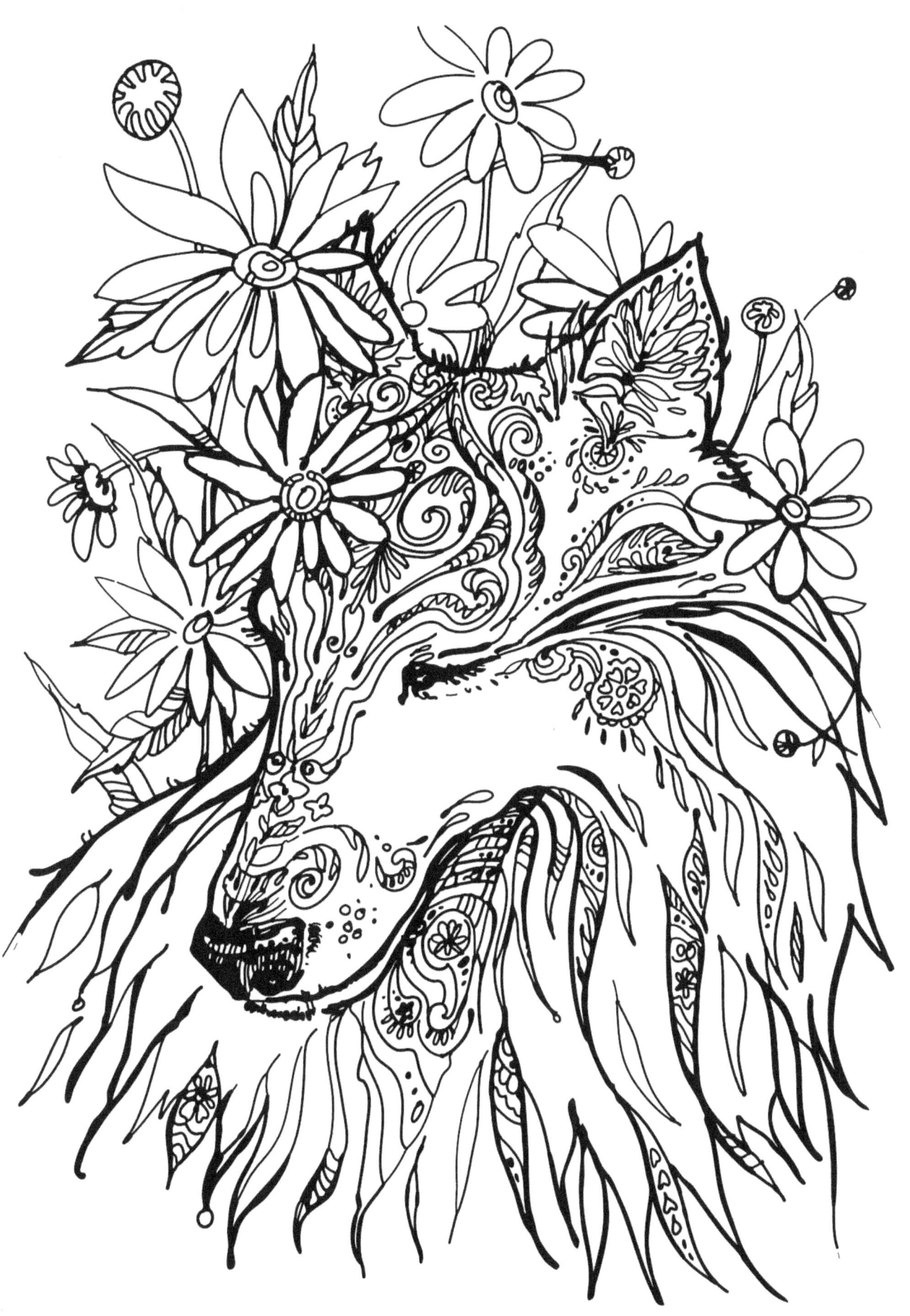

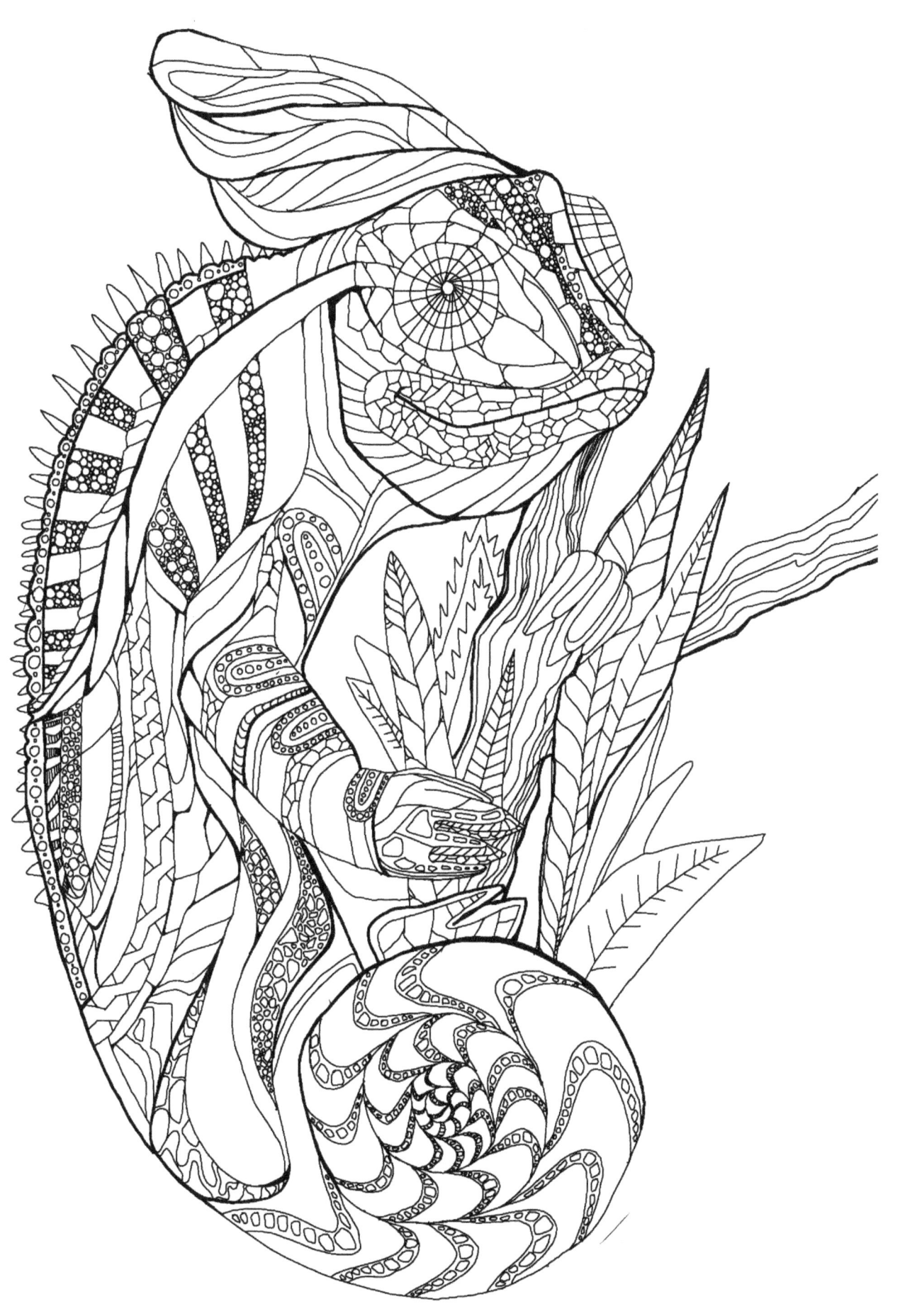

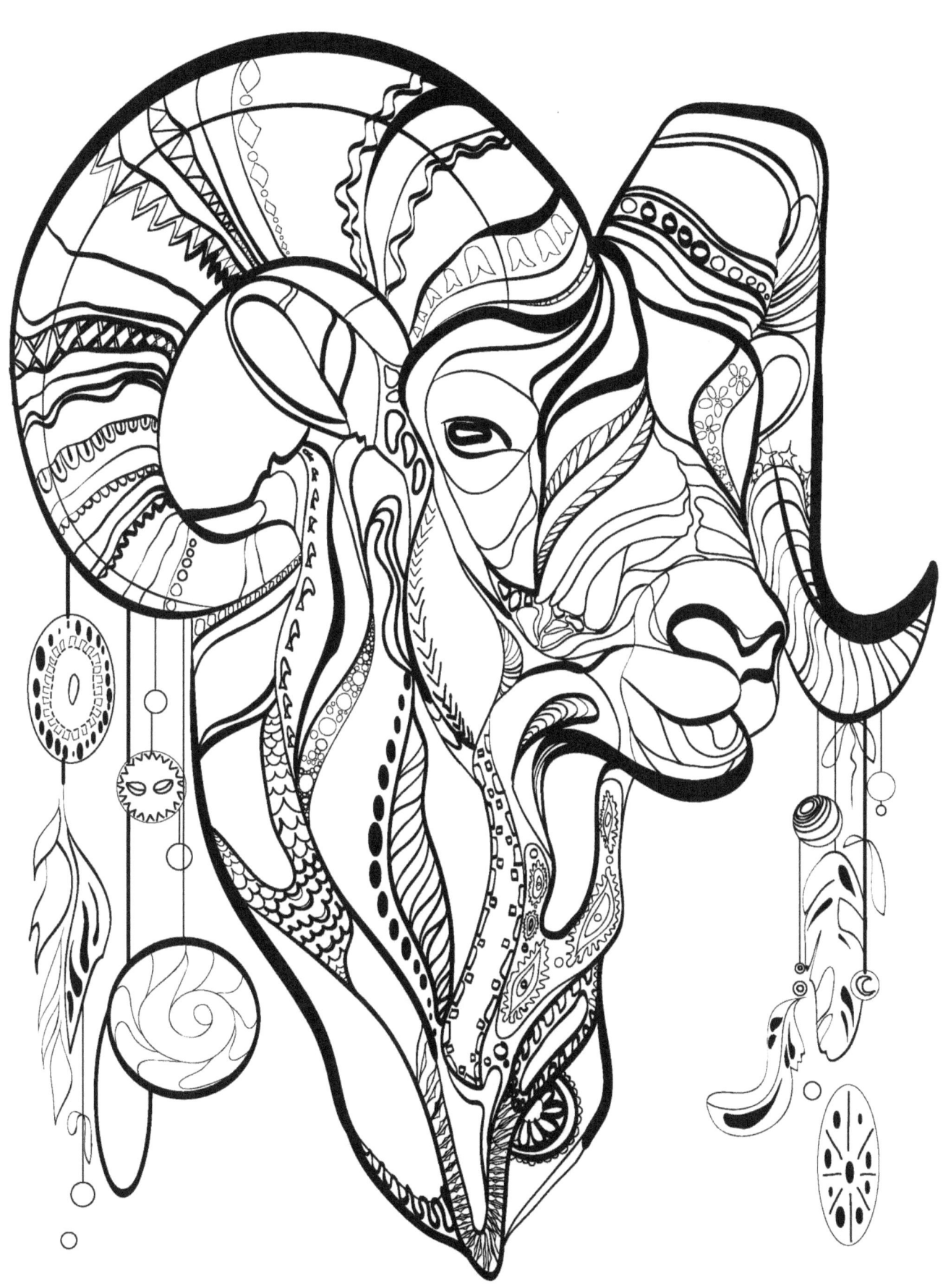

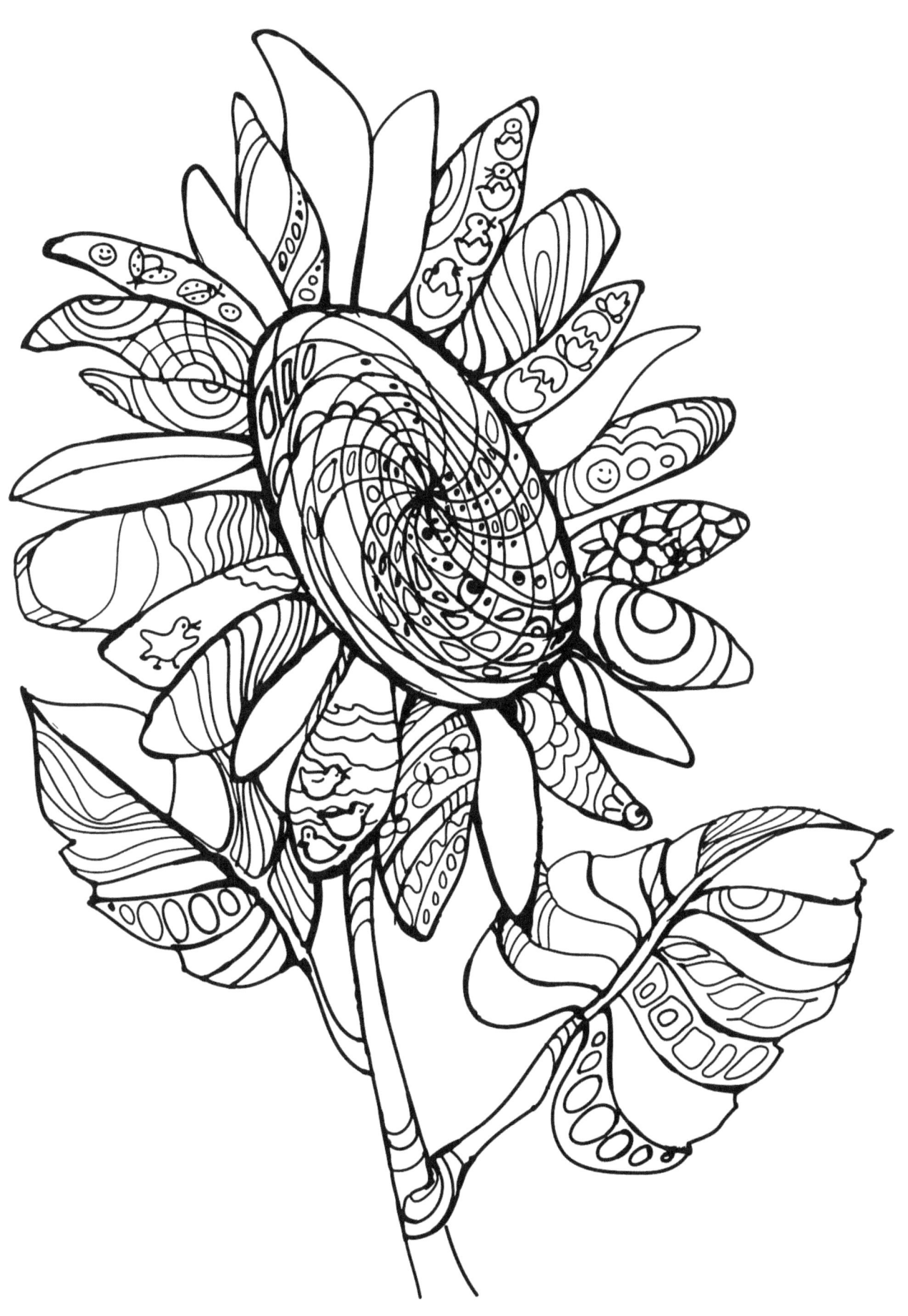

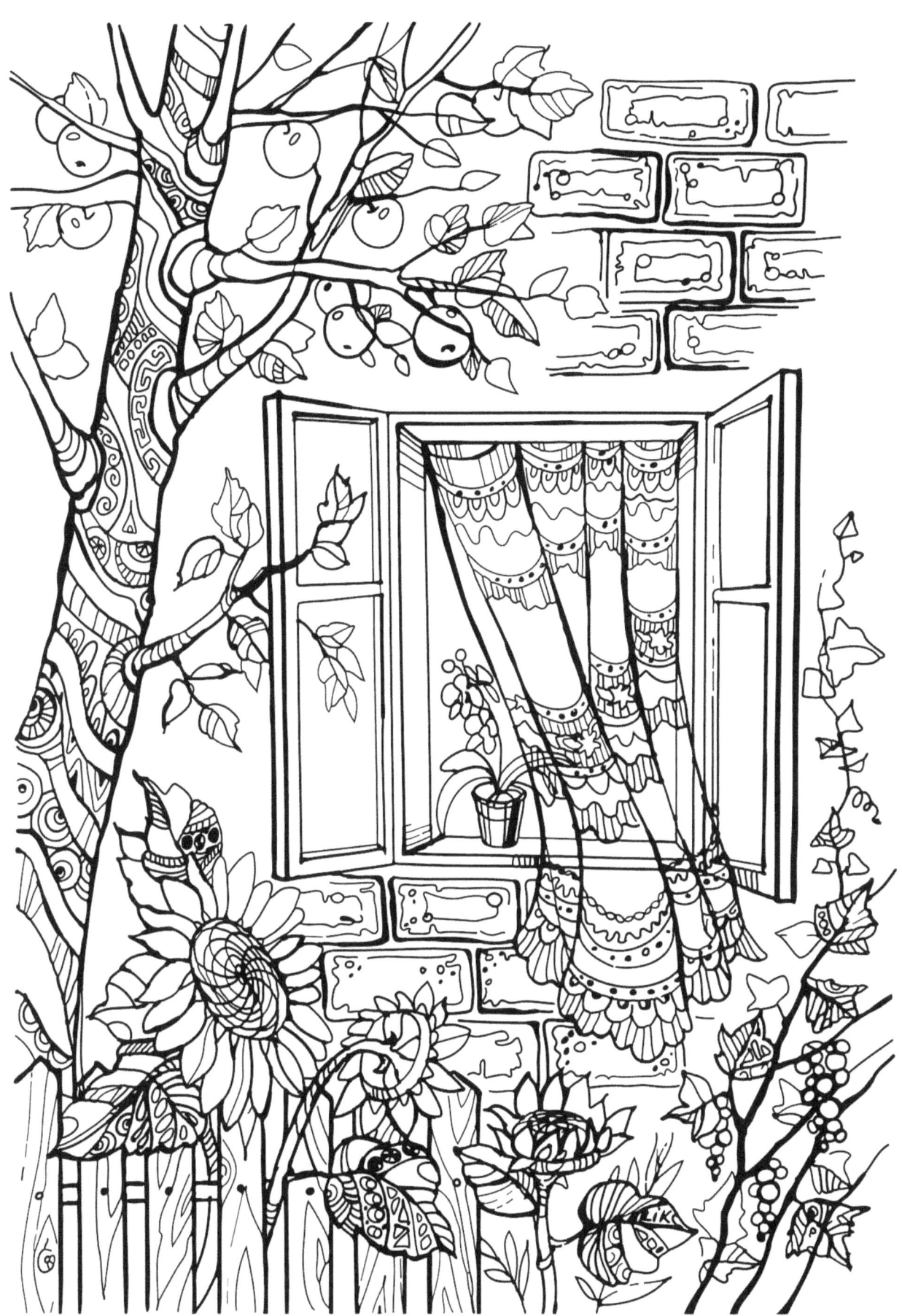

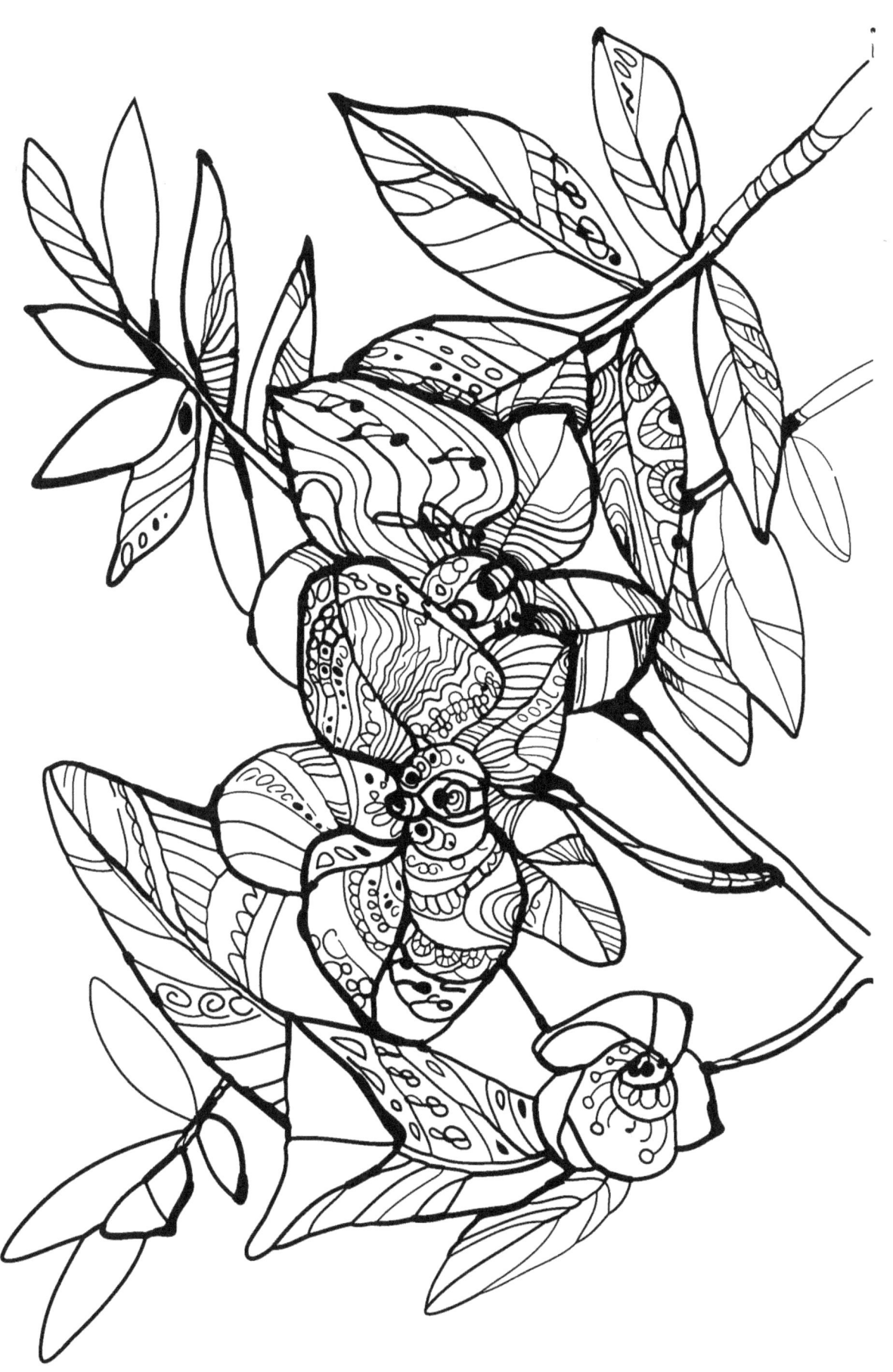

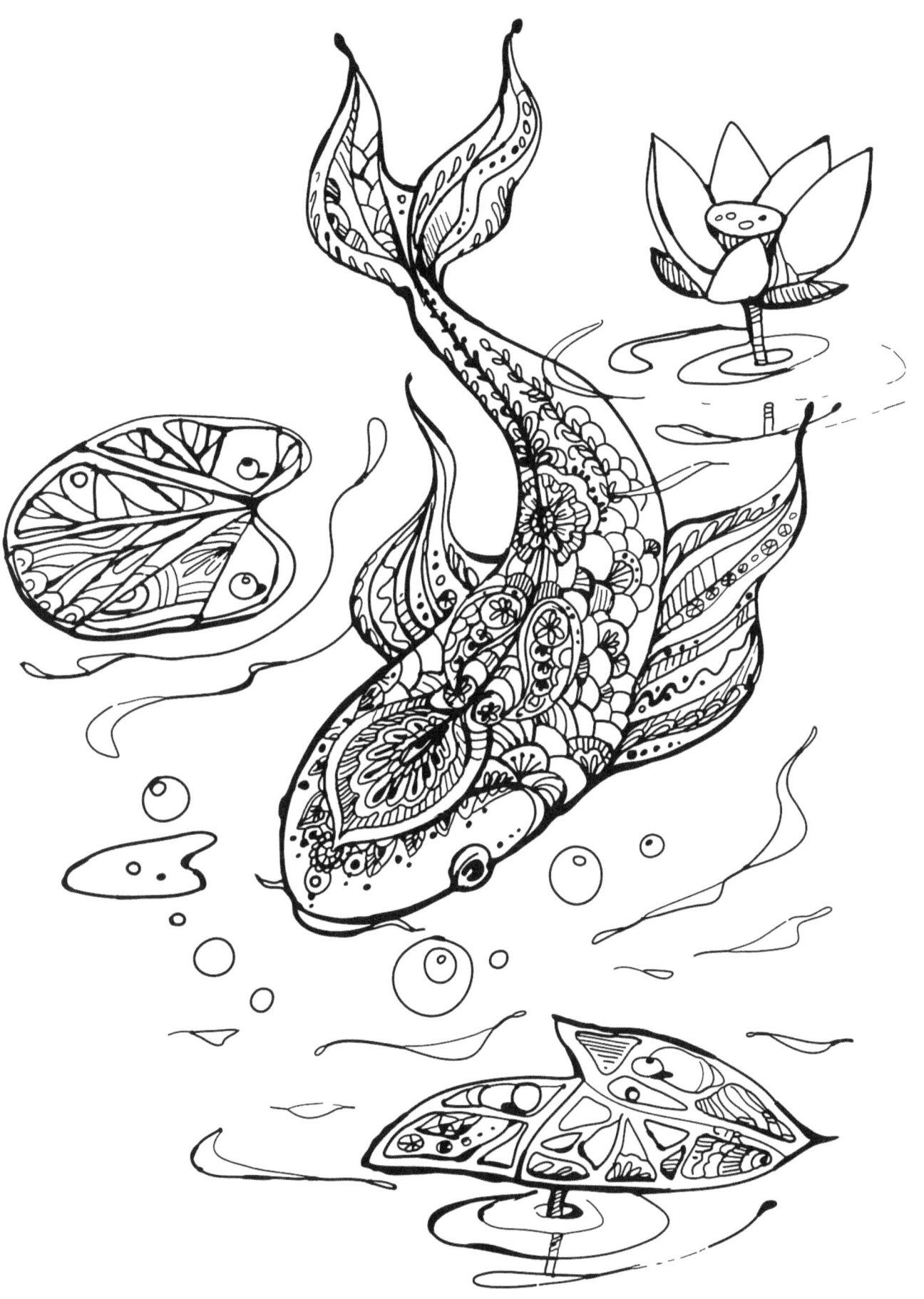

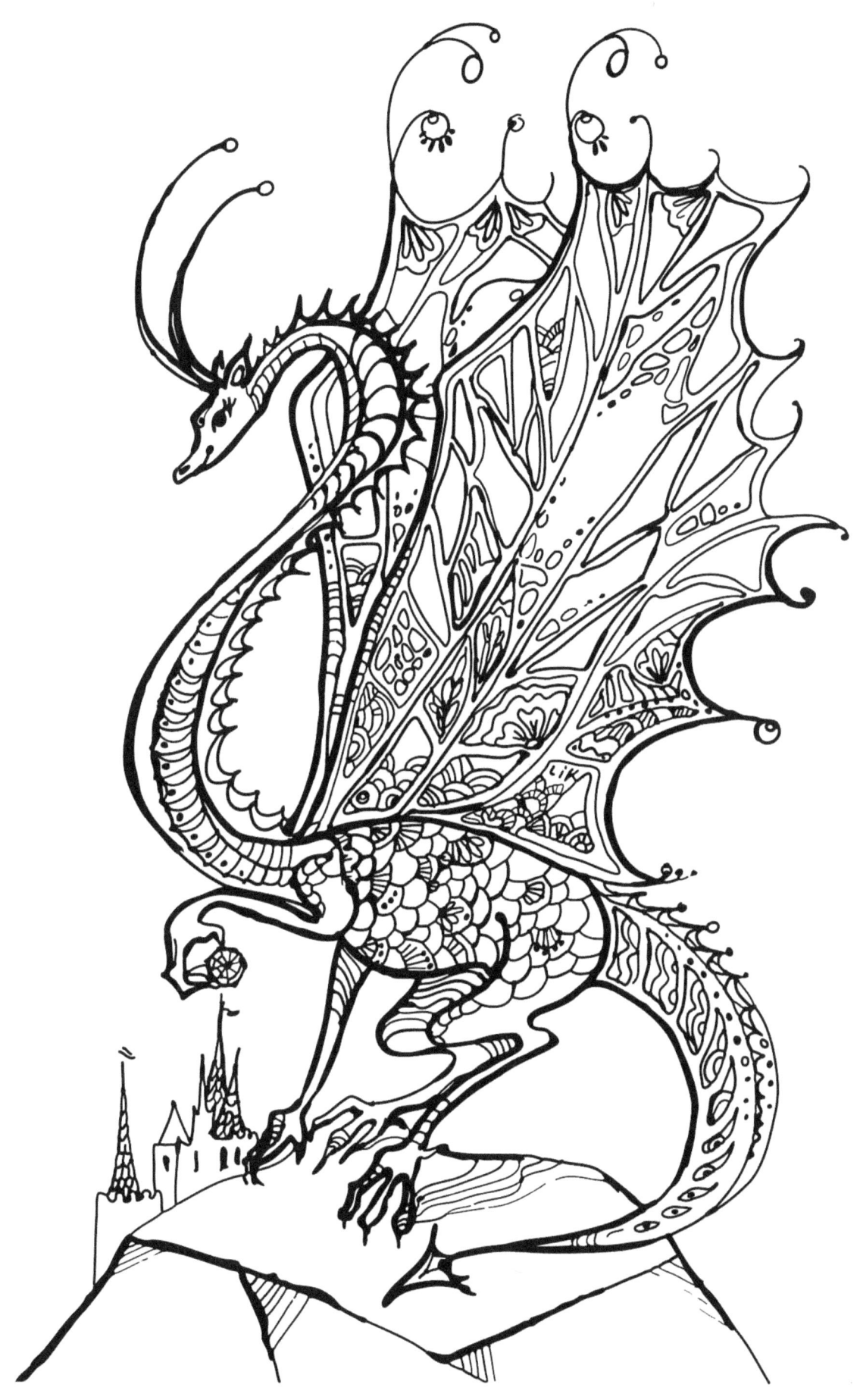

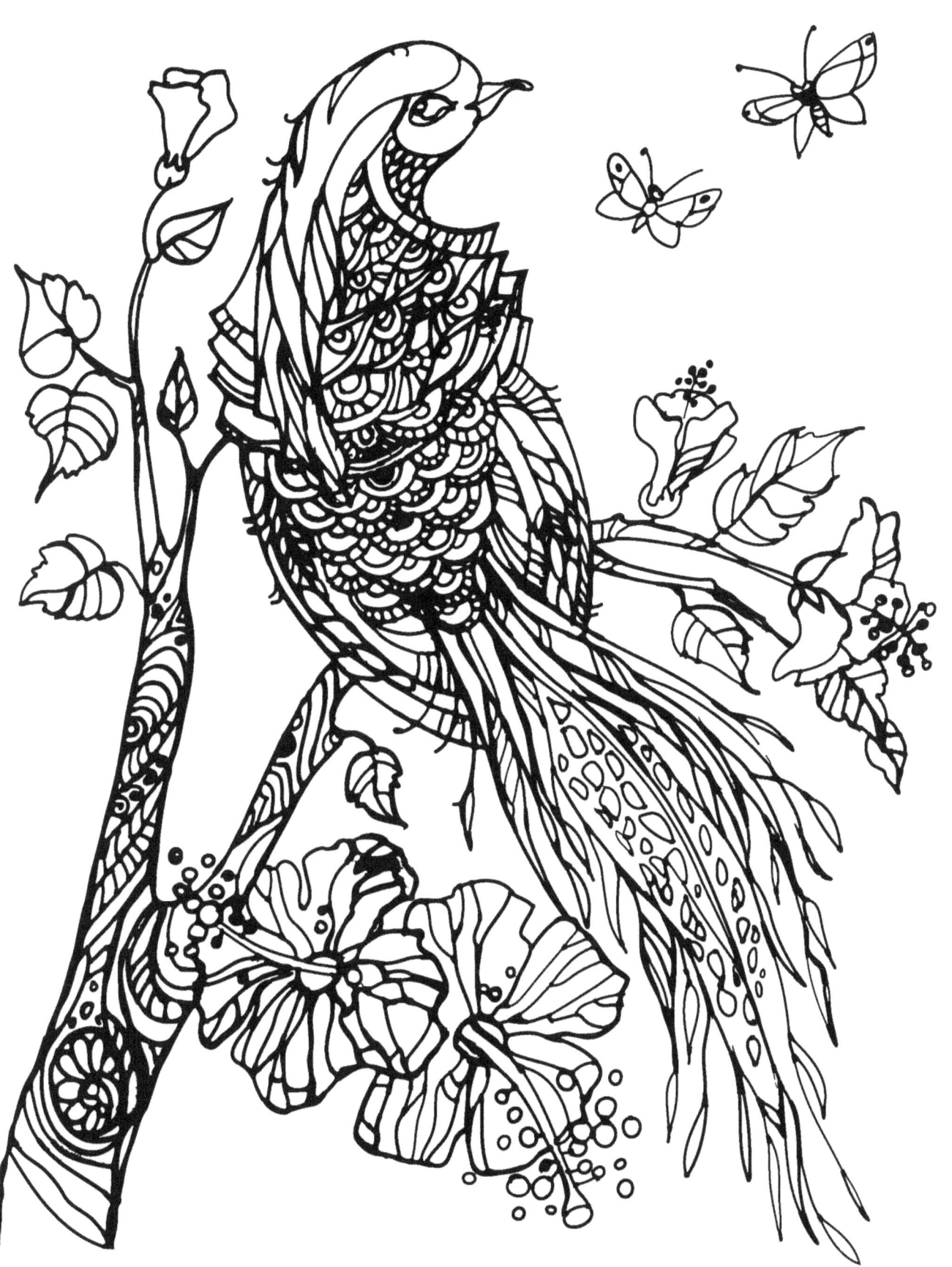

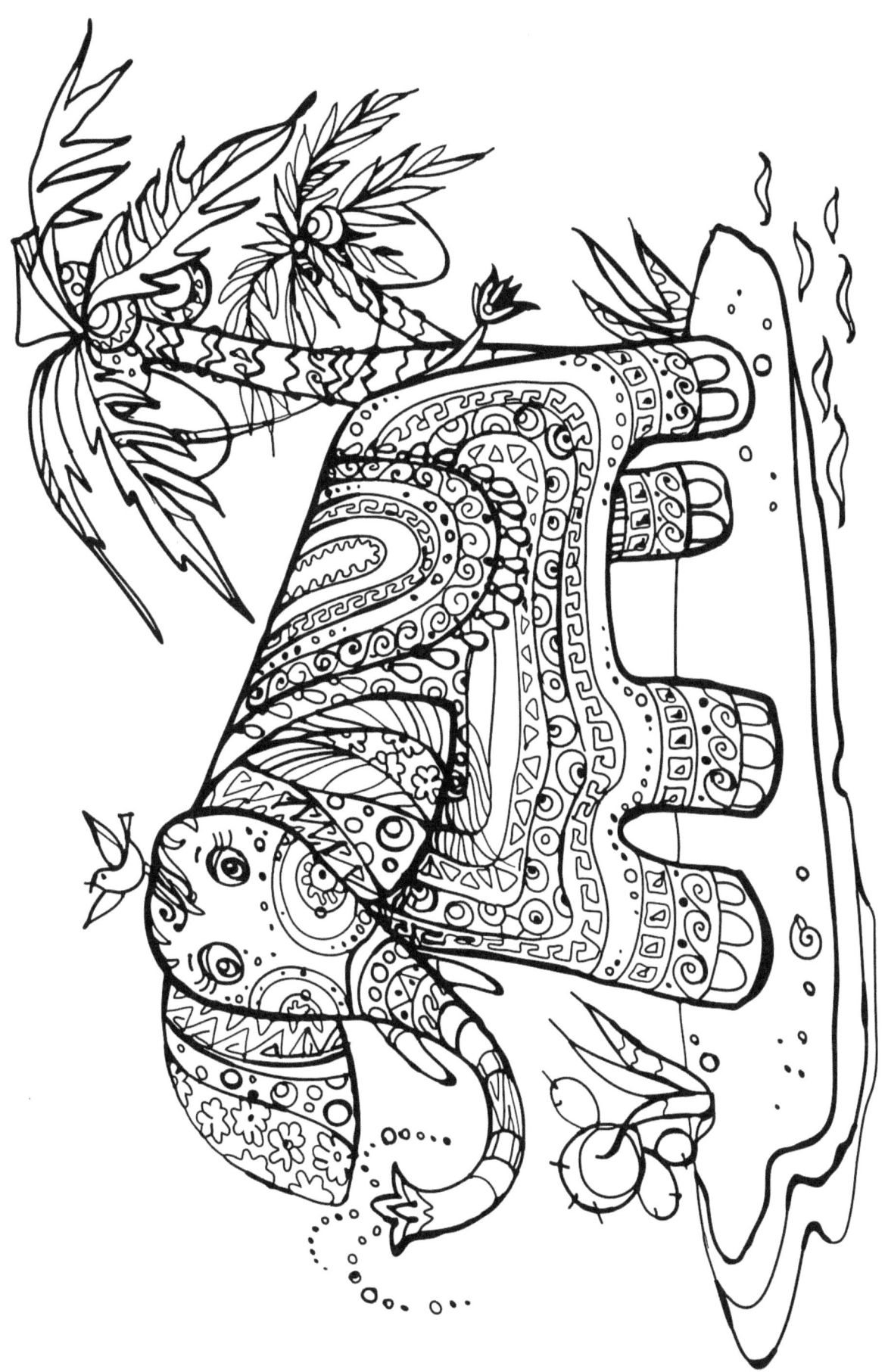

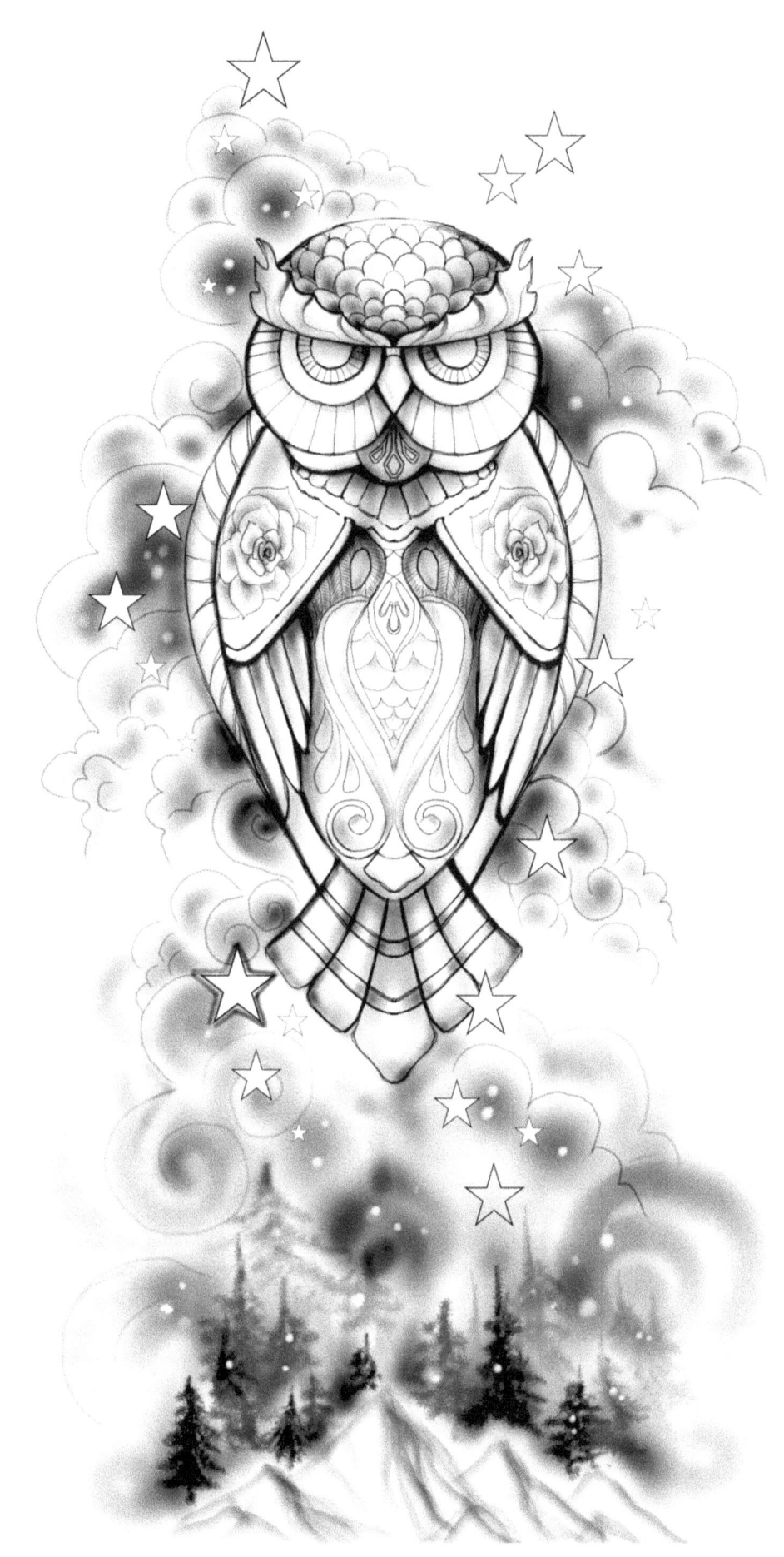

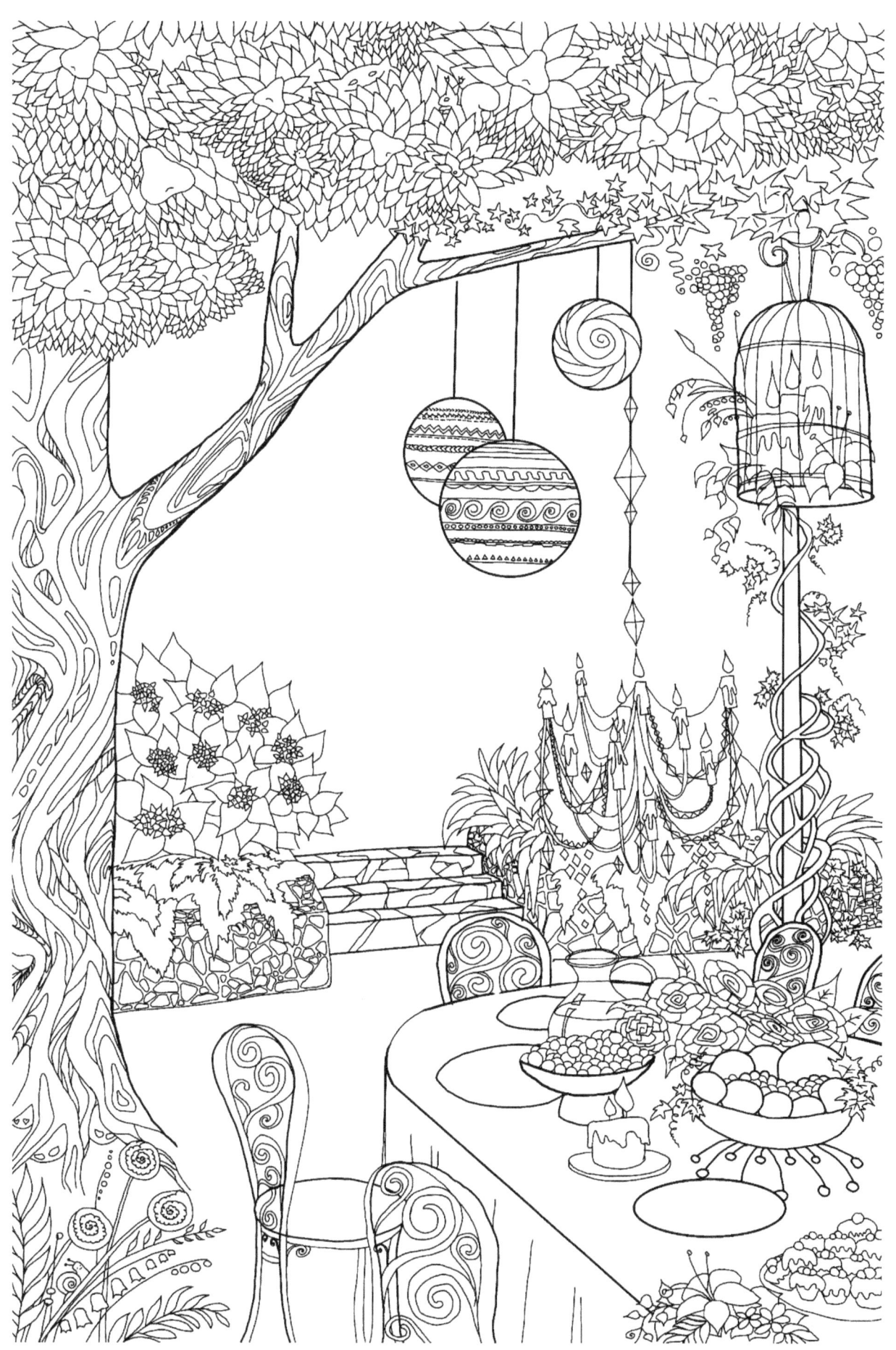

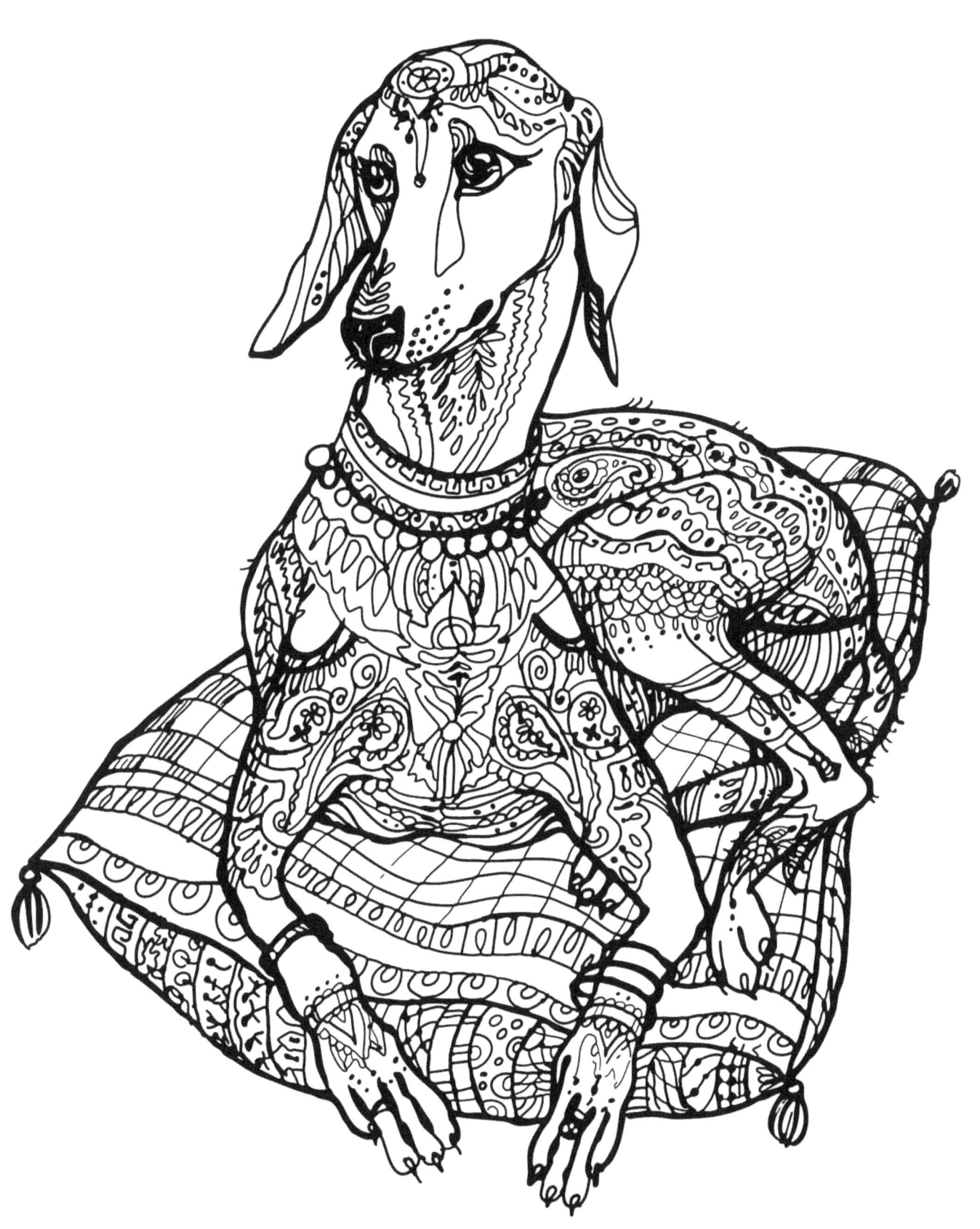

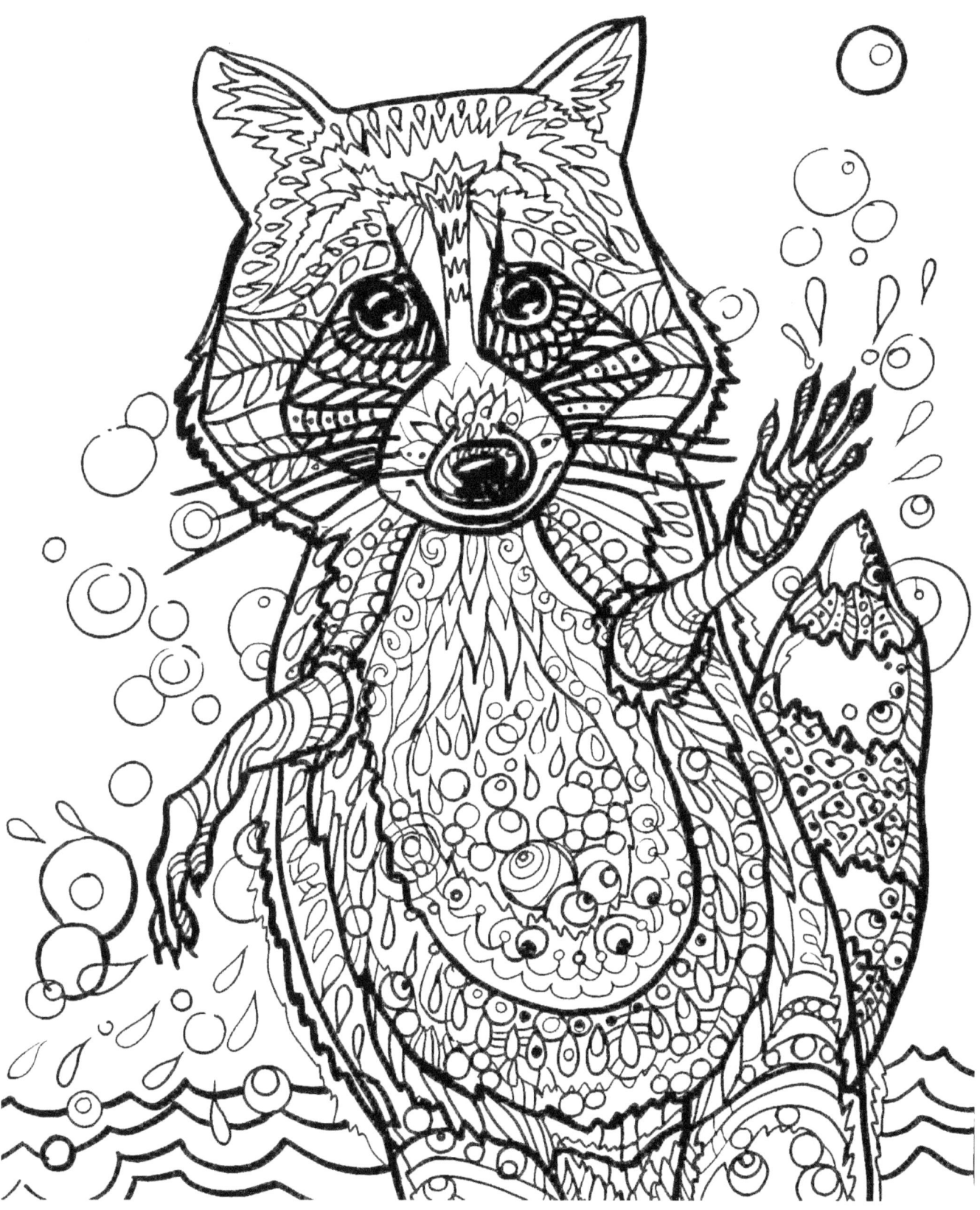

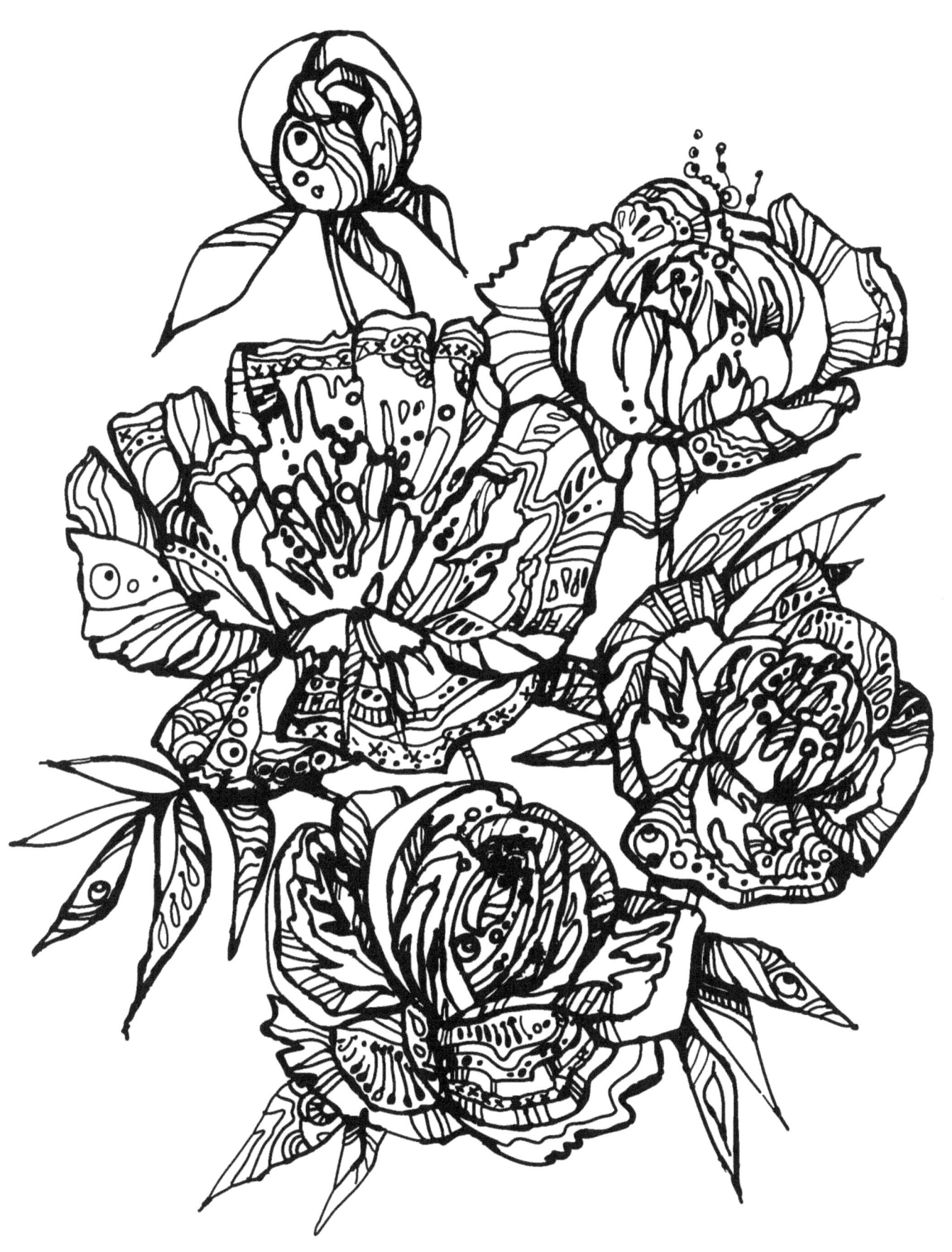

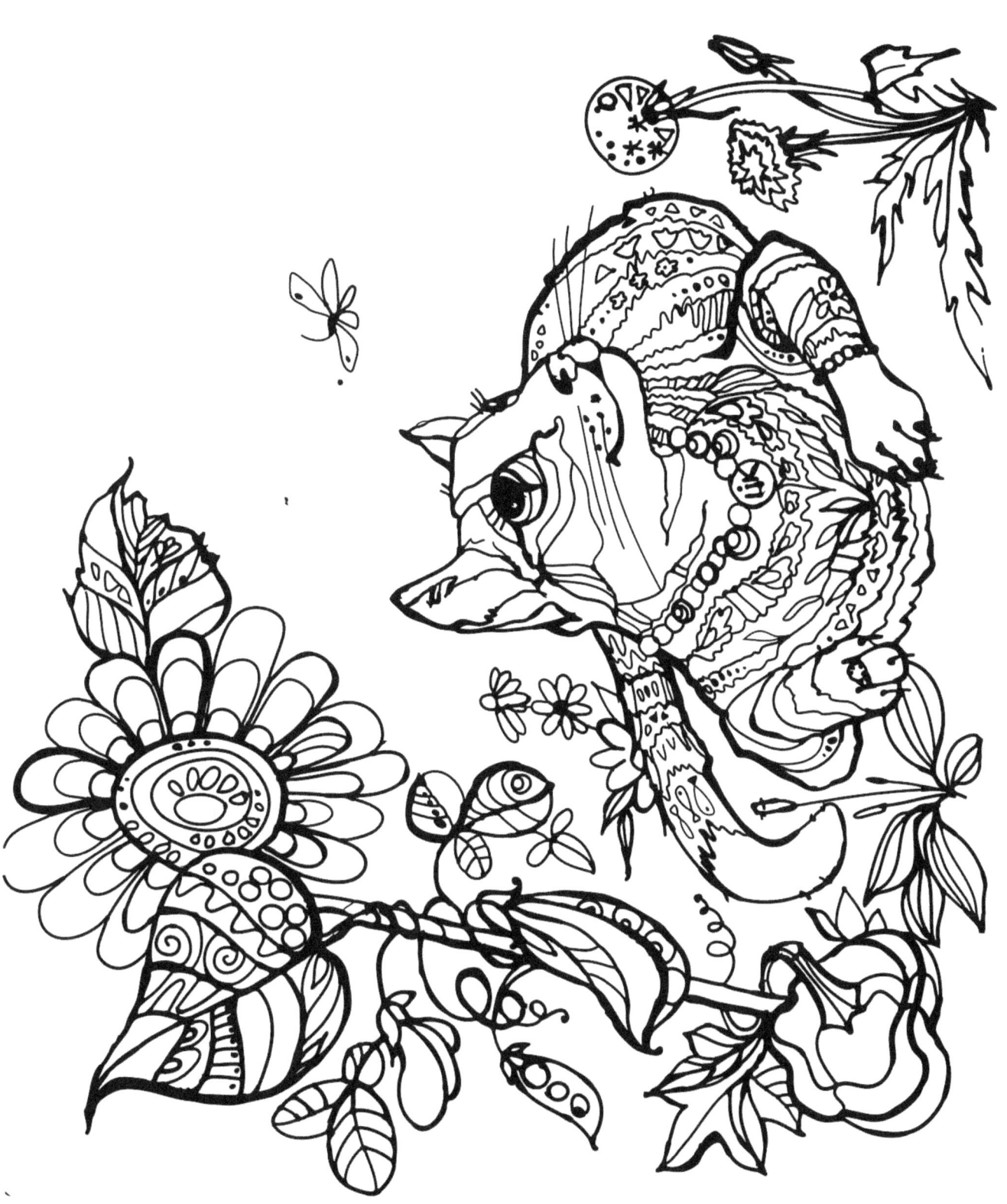

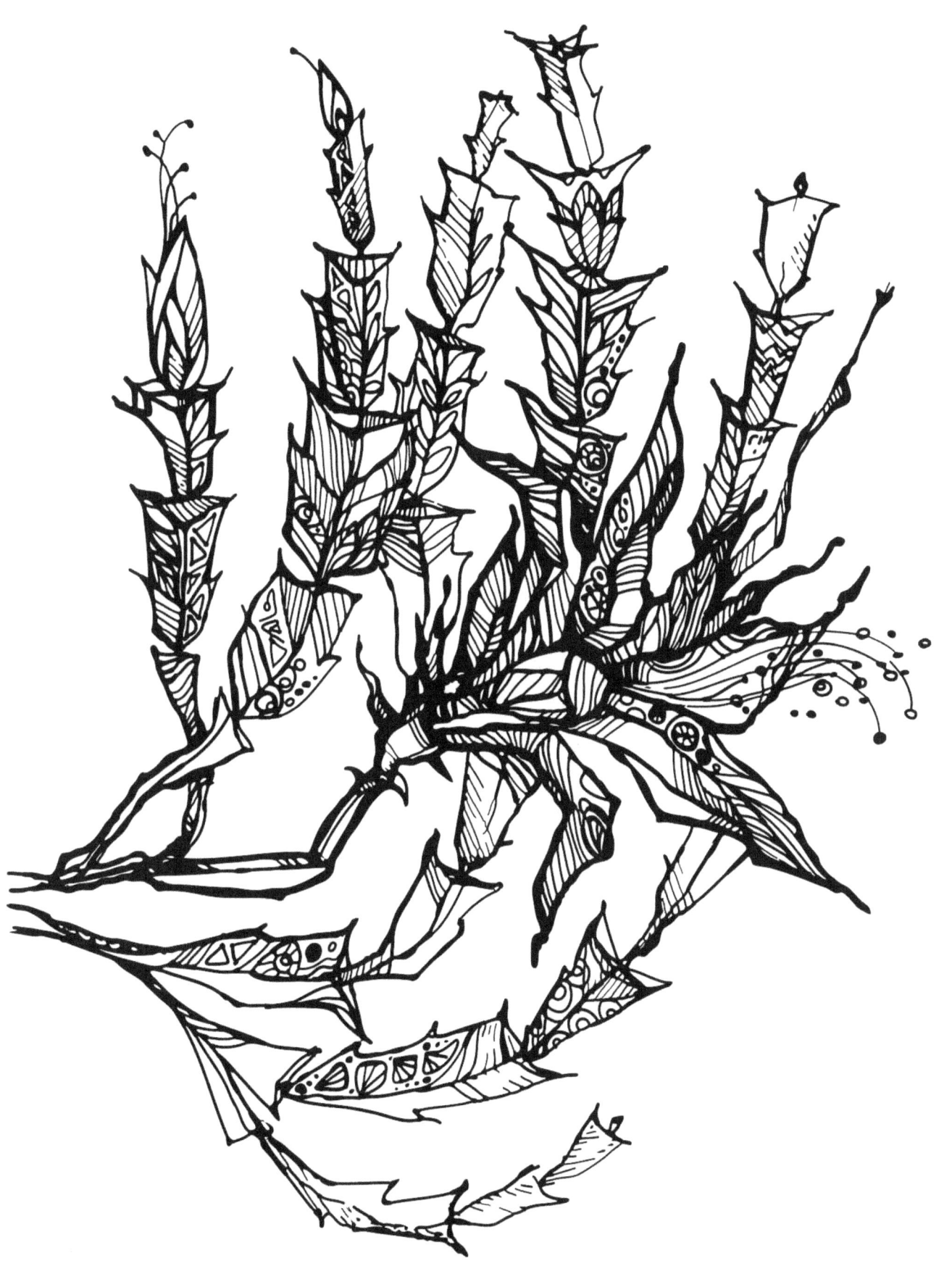

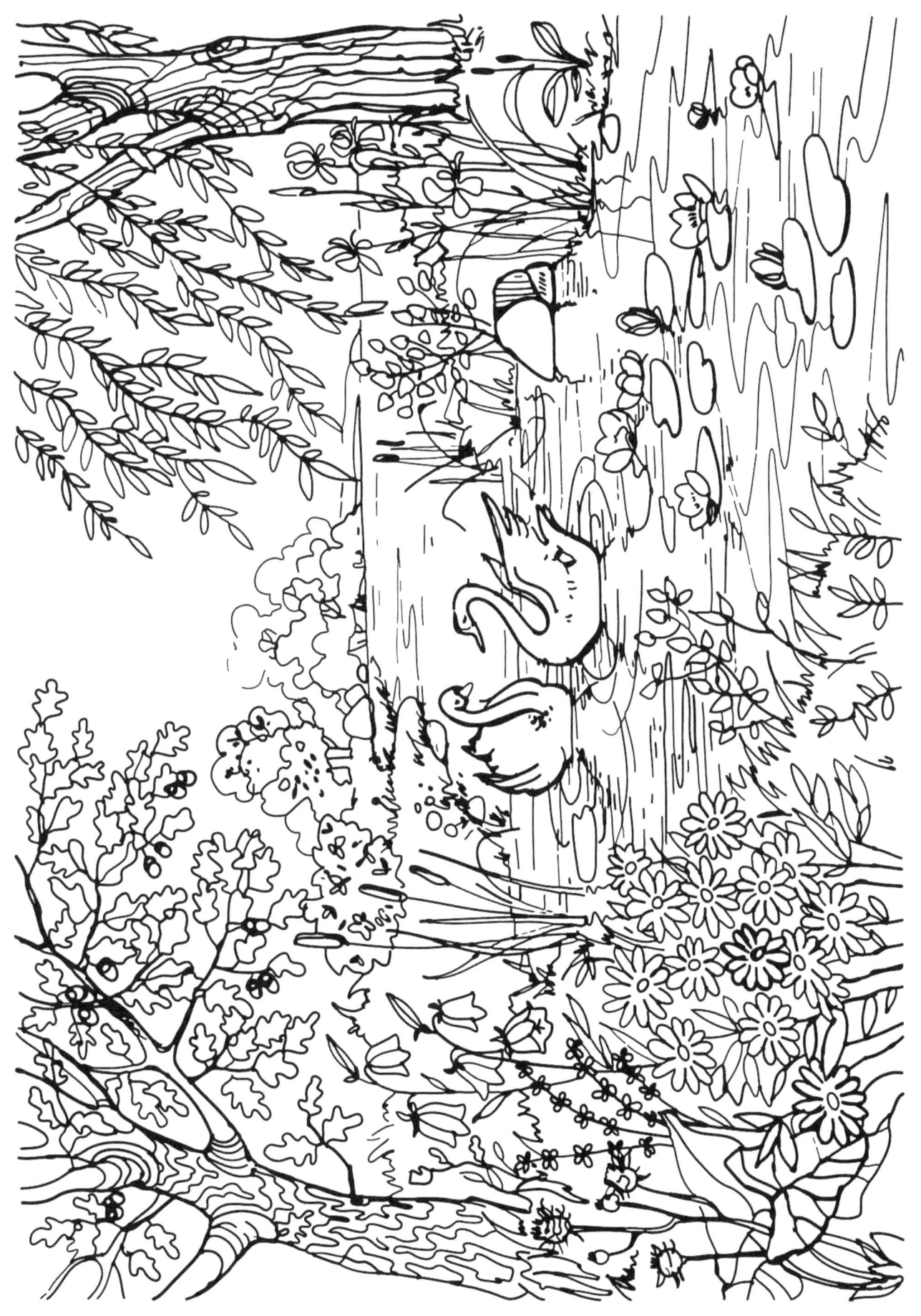

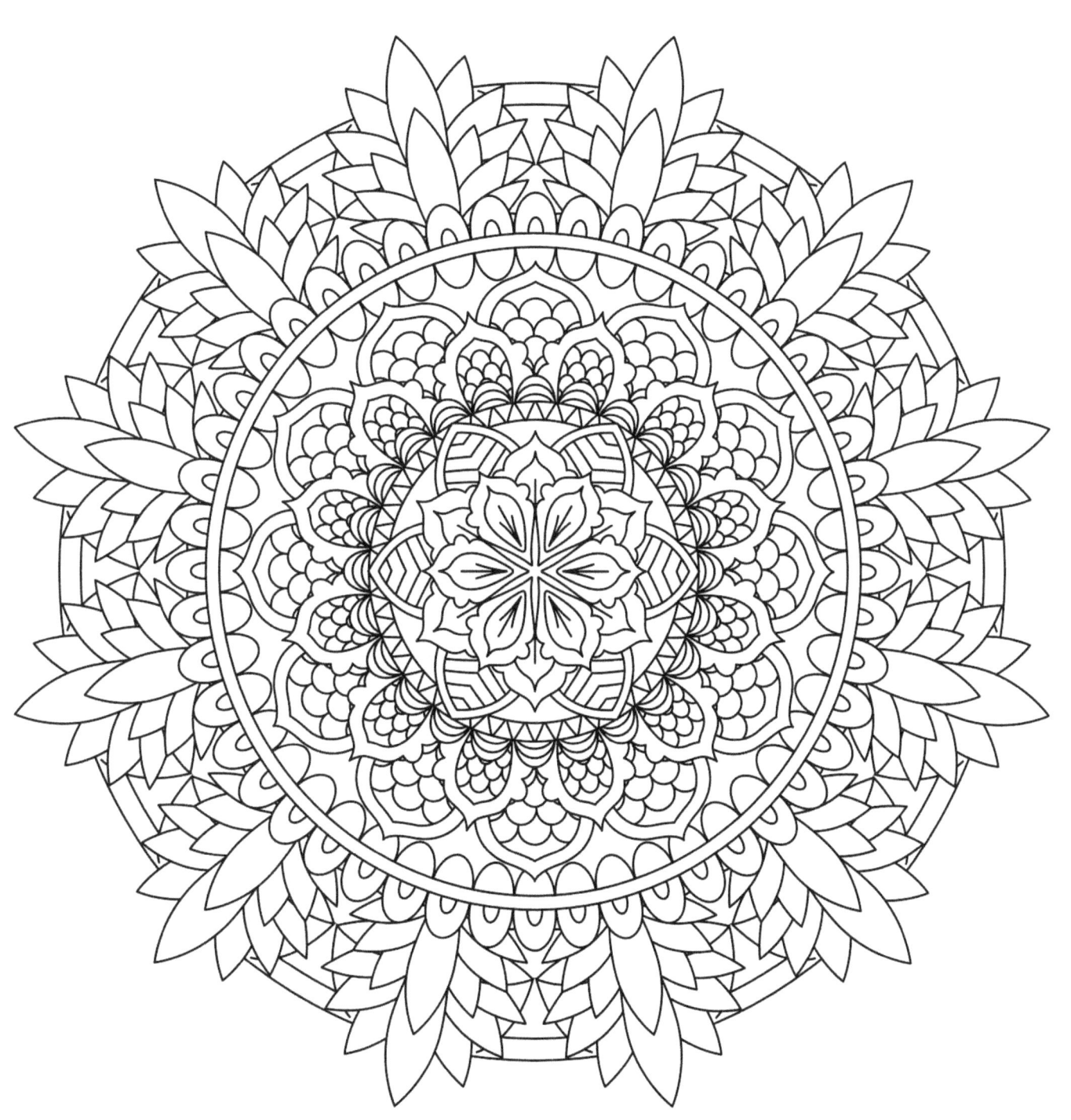

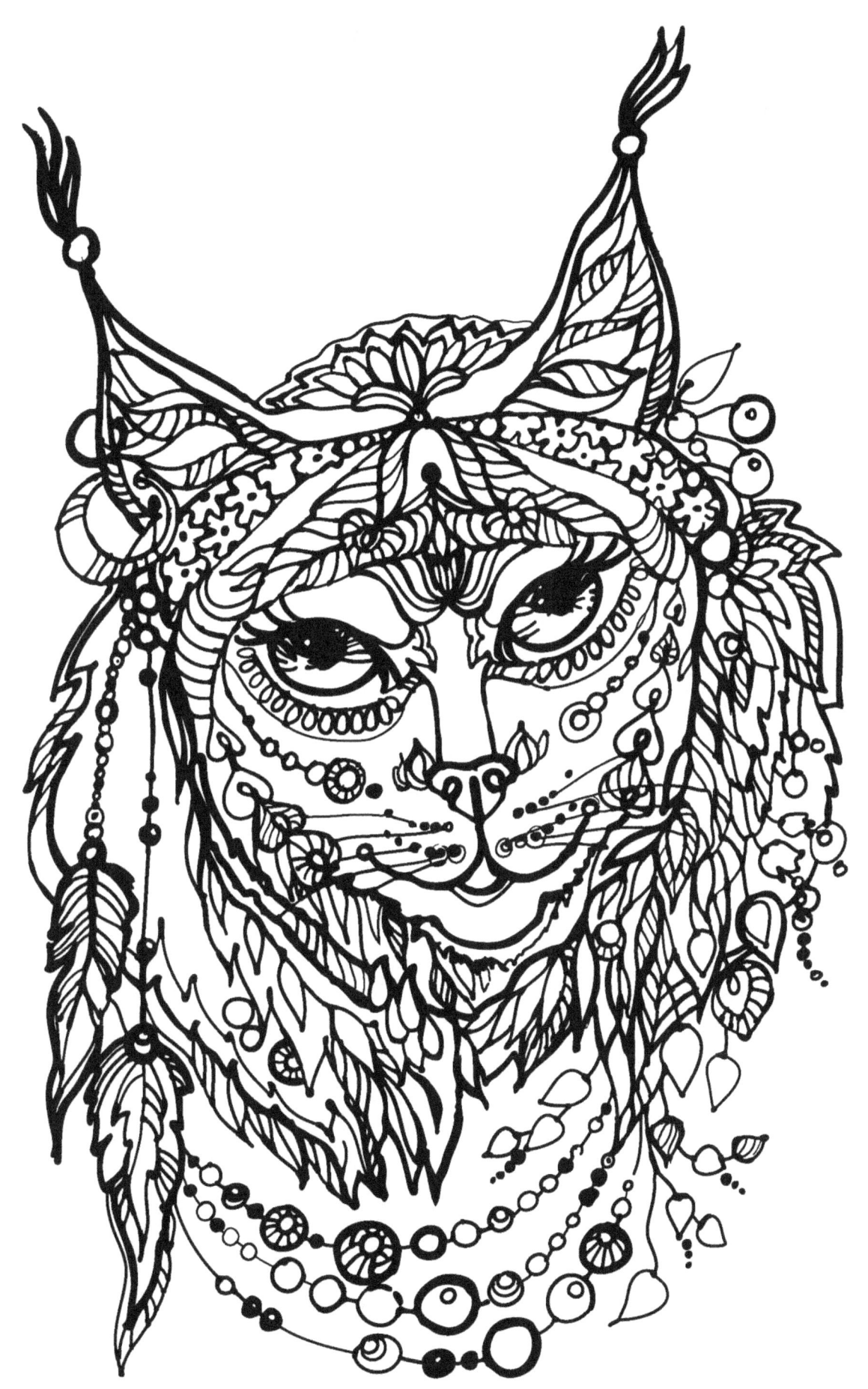

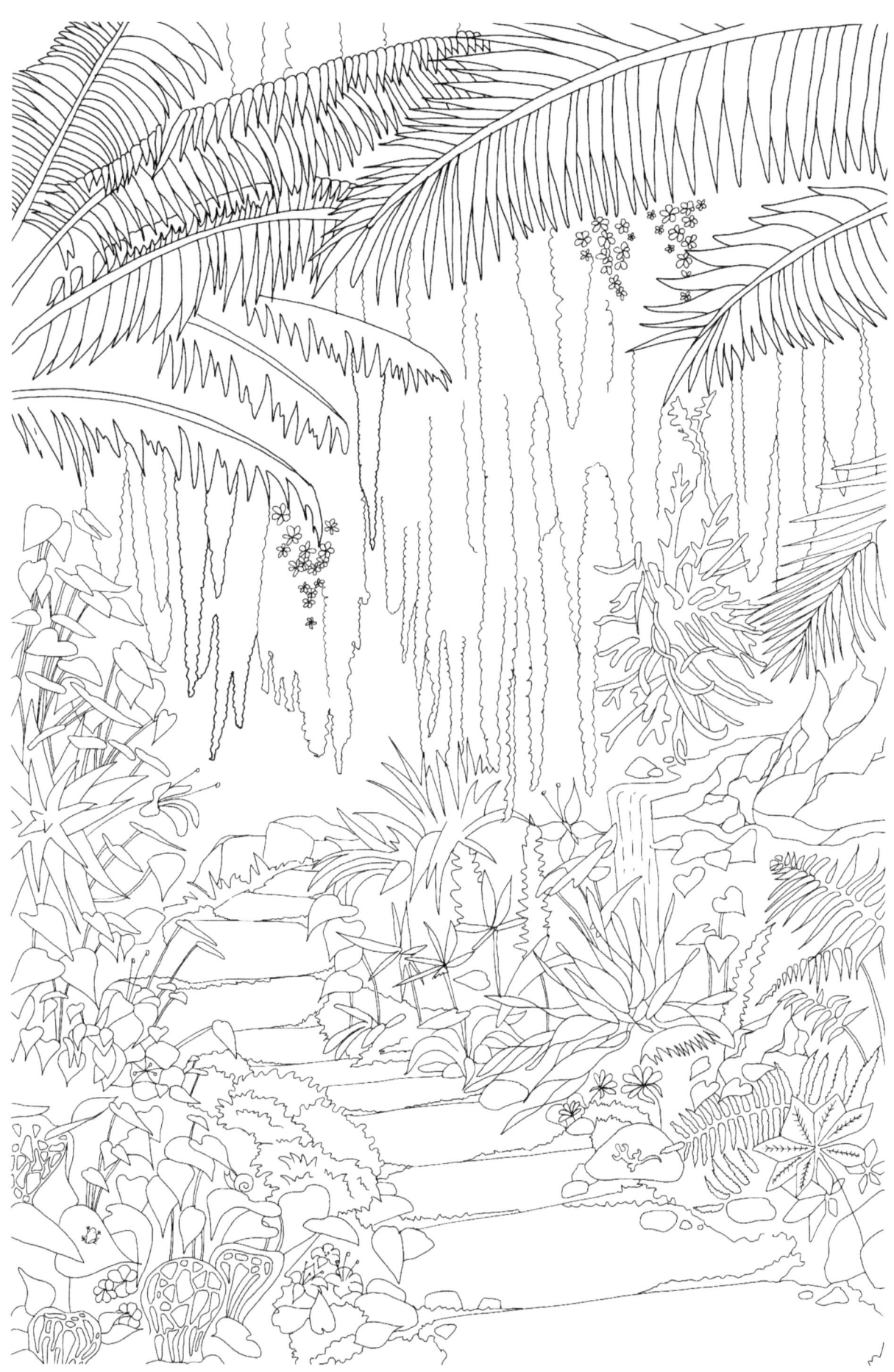

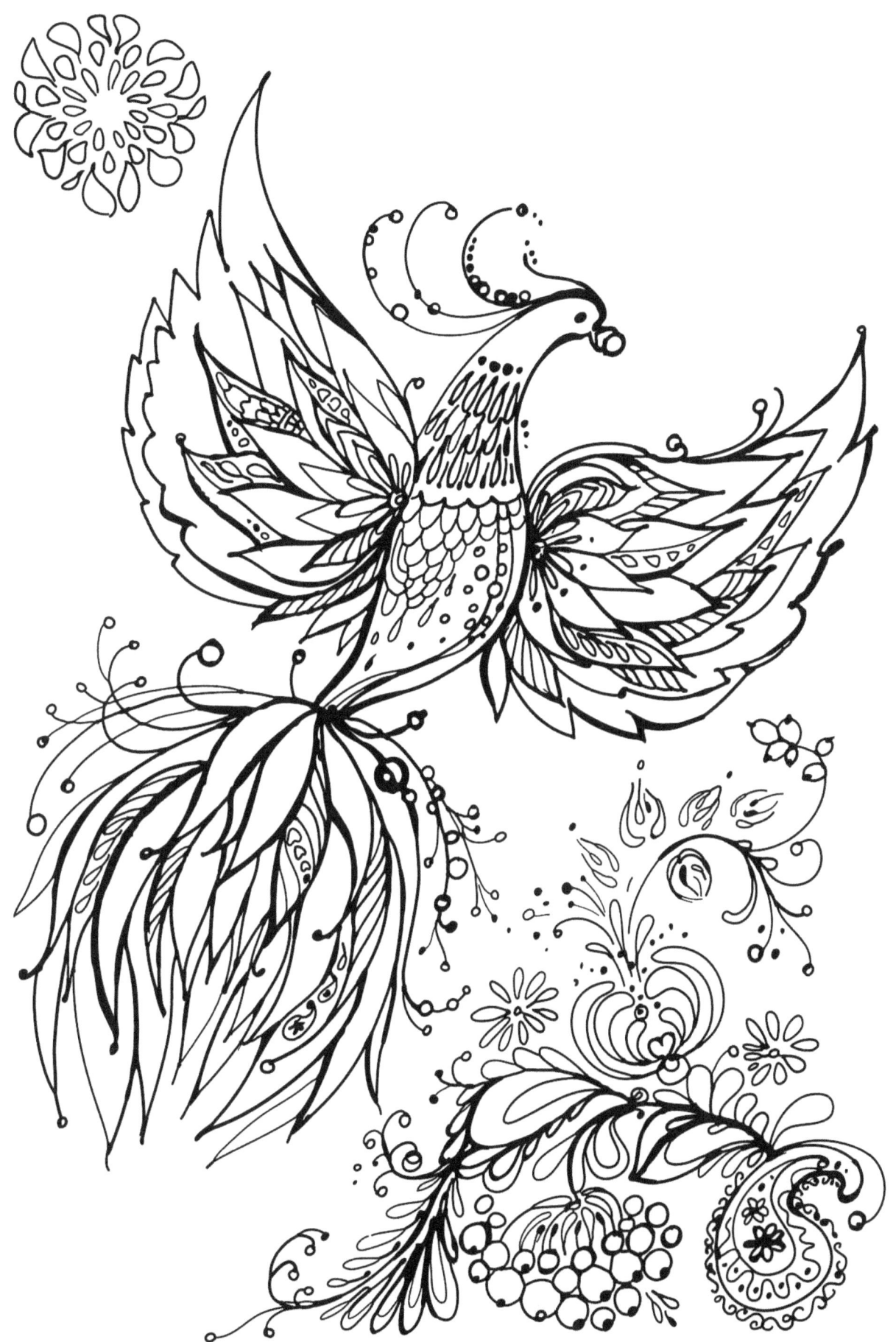

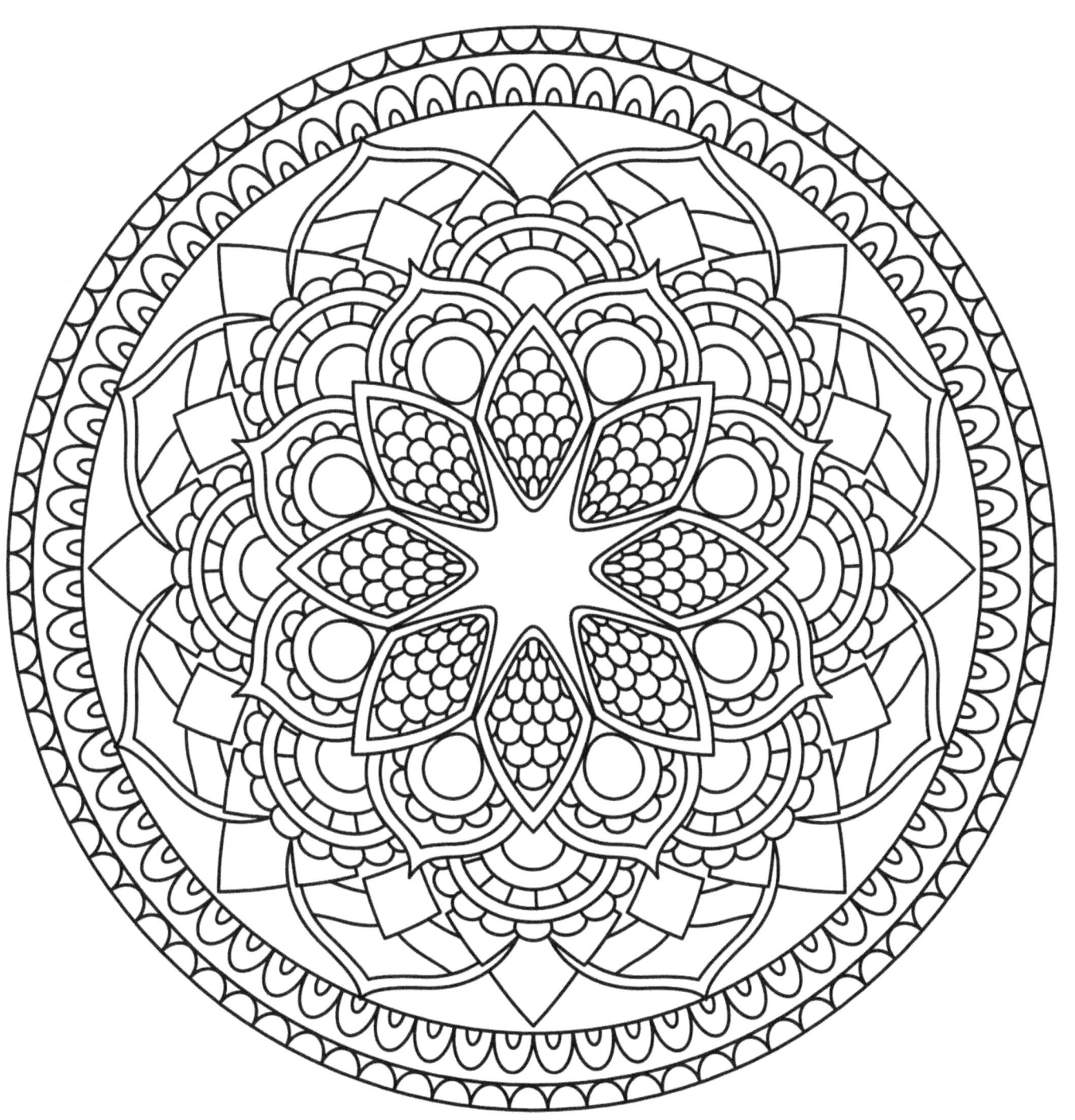

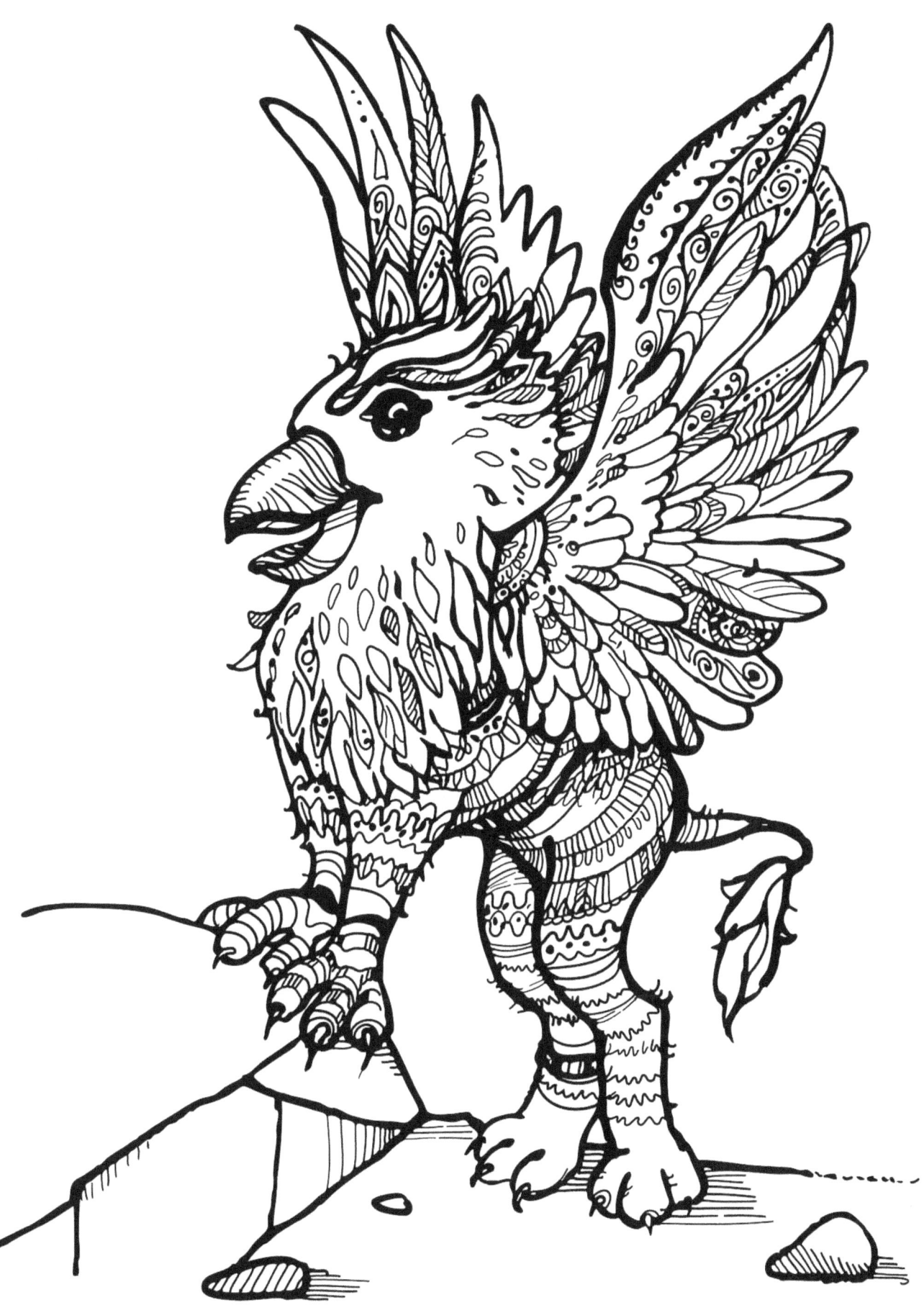

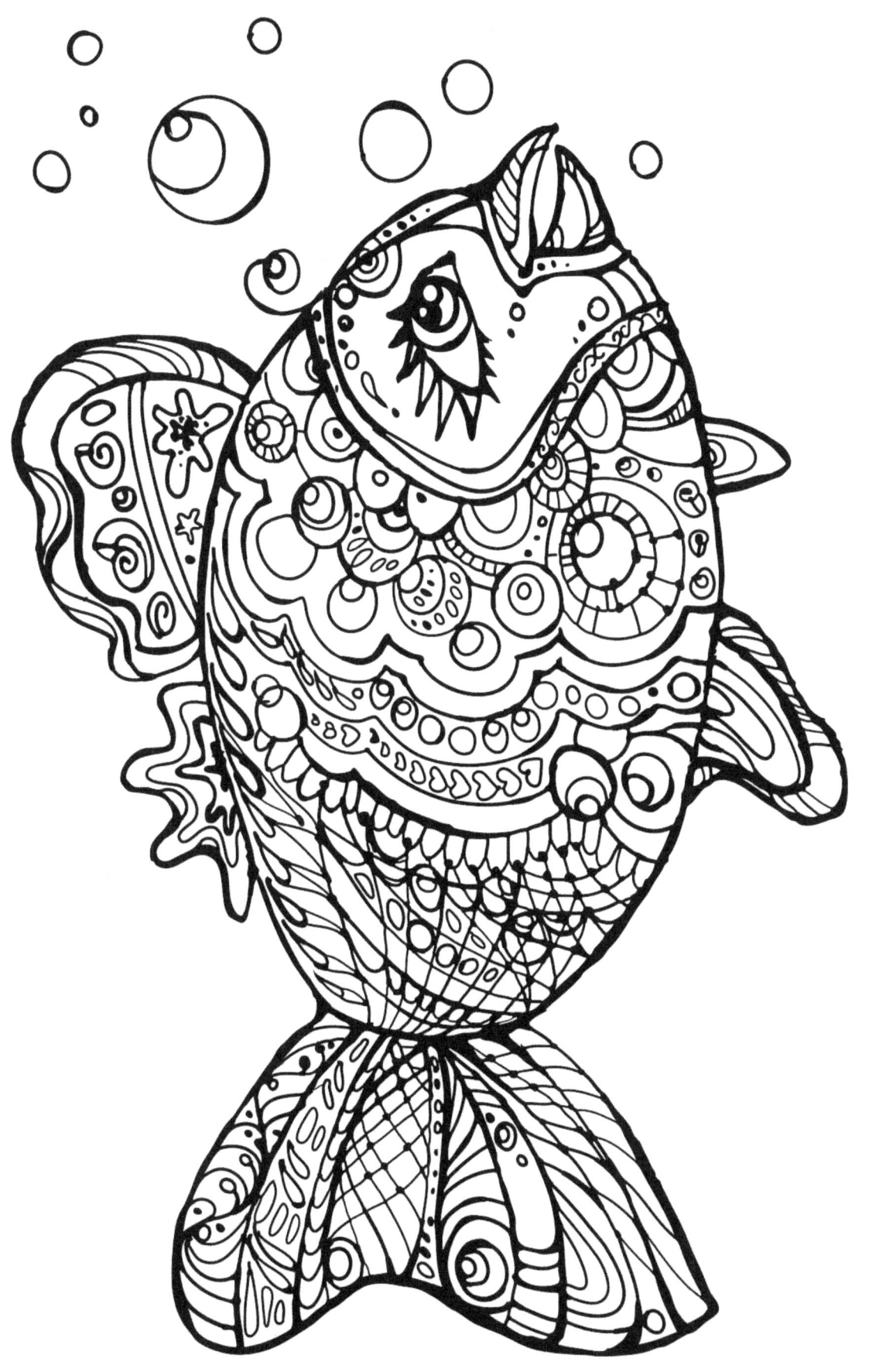

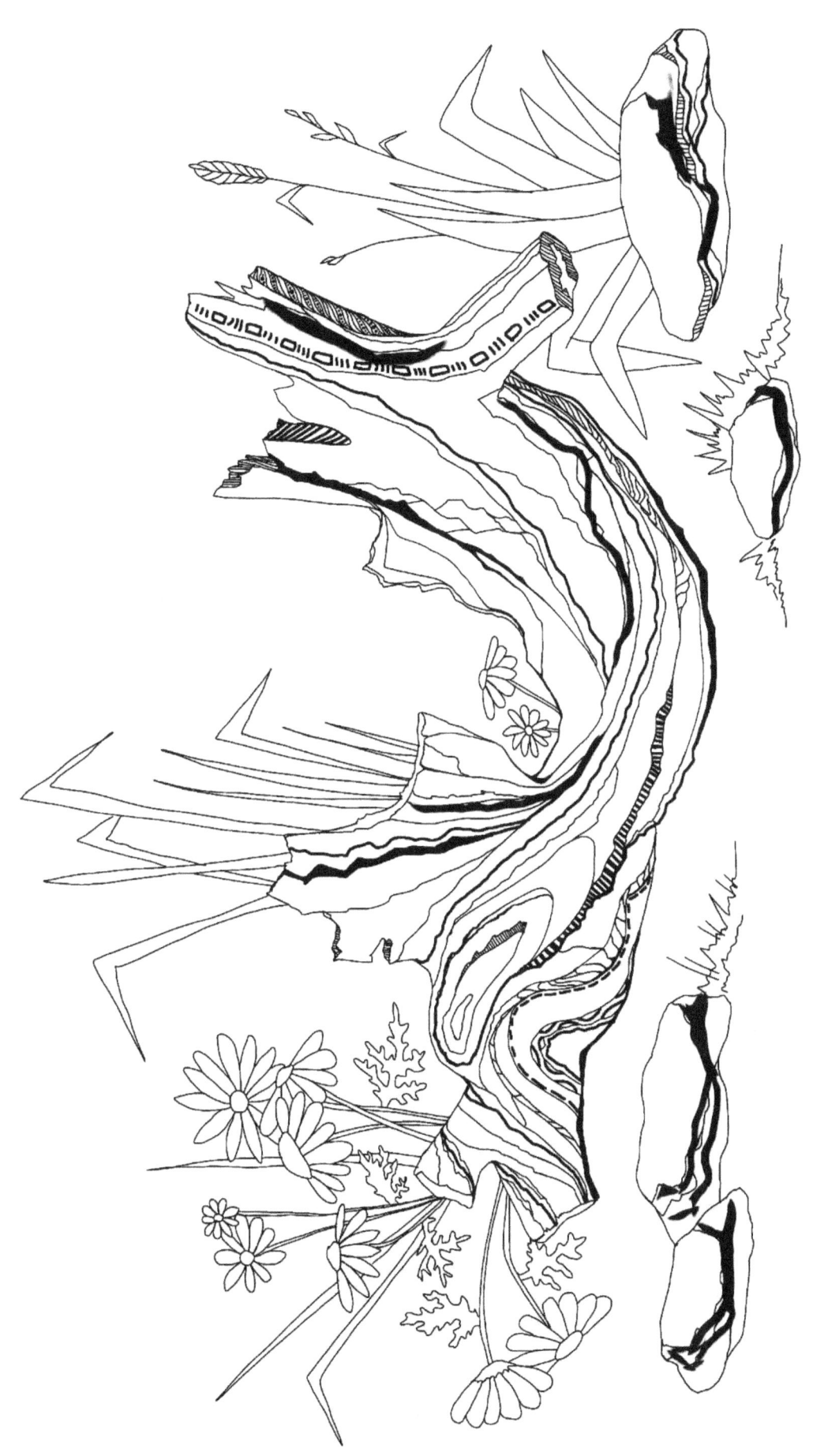

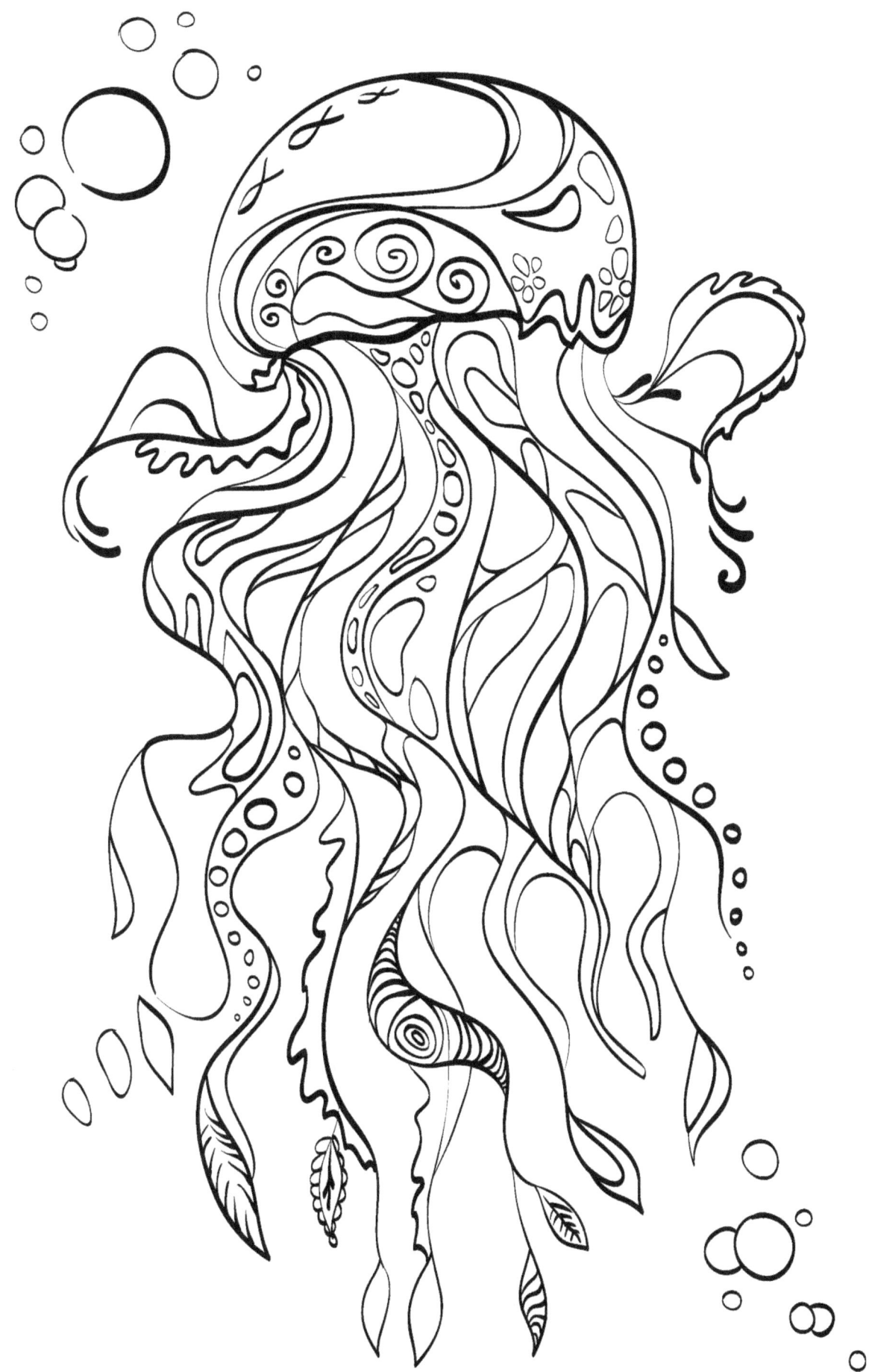

Your free gift

http://bit.ly/free-gift-keep-calm-for-mental-health

Join us on social networks (Fosten Art)

 facebook.com/Coloring-Book-by-Fosten-Art-167597577011423

 plus.google.com/u/0/102307891885395928430/

 pinterest.com/fostenart/